Arts-Based Research
PRIMER

This book is part of the Peter Lang Education list.
Every volume is peer reviewed and meets
the highest quality standards for content and production.

PETER LANG
New York • Washington, D.C./Baltimore • Bern
Frankfurt • Berlin • Brussels • Vienna • Oxford

James Haywood Rolling, Jr.

Arts-Based Research
PRIMER

PETER LANG
New York • Washington, D.C./Baltimore • Bern
Frankfurt • Berlin • Brussels • Vienna • Oxford

Library of Congress Cataloging-in-Publication Data
Rolling, James Haywood.
Arts-based research primer / James Haywood Rolling, Jr.
pages cm. — (Peter Lang primers)
Includes bibliographical references and index.
1. Qualitative research—Methodology. 2. Arts and society. I. Title.
H62.R638 001.4'2—dc23 2013005247
ISBN 978-1-4331-1649-0 (paperback)
ISBN 978-1-4539-1086-3 (e-book)

Bibliographic information published by **Die Deutsche Nationalbibliothek**.
Die Deutsche Nationalbibliothek lists this publication in the "Deutsche
Nationalbibliografie"; detailed bibliographic data is available
on the Internet at http://dnb.d-nb.de/.

© 2013 Peter Lang Publishing, Inc., New York
29 Broadway, 18th floor, New York, NY 10006
www.peterlang.com

Printed in the United States of America

Contents

A Paradigm Analysis of Arts-Based Research

Initial Sketches

Theory/*Theōria*
A representative construction—or re-construction—of a phenomenon of life shaped as a set of interrelated constructs represented in a distinguishable manner or form in order to describe, explain, and/or interpret the variables and variability of an experience within the world.

Praxis/Prattein
Praxis is the sum total of our moral and artistic activities; the enactment, practice, embodiment, or realization of our individual and collective contemplation and speculation regarding the experience of social life within the natural world.

The purpose of arts-based research (ABR), like all research, is theory-building. Theory—a word that has its origin via late Latin from the Greek word *theōria*—involves the "contemplation" or "speculation" of natural laws and phenomena of life. Ultimately, a theory is a representation of experience so that others may also acknowledge and understand. Theory is distinguished from the word praxis, which takes its origin from the Greek language via medieval Latin; praxis literally means "doing," from the word *prattein*. According to Aristotle, theorizing suggests a rational exercise that occurs at *rest* from the moral and artistic activities, or doings, of humankind. Theories are conveyed as representative constructs—or reconstructions—of the experiential worlds of the researcher, both lived and speculative. Theoretical reconstructions of experience may be conceptual, transcribed, or physically manufactured.

The associated concepts, definitions, assumptions that constitute a theory either naturally cohere, or are otherwise fabricated, to act as enduring filters, lenses and/or models making sense of lived contexts. Borrowing from both Kerlinger (1986) and Hoy (2010), a theory may be succinctly defined as *a set of interrelated constructs represented in a distinguishable manner or form, the major function of which is to describe, explain, and/or interpret the variables and variability of a phenomenon or experience within the world.* While theories are built up initially as abstractions representing our most basic apprehensions of the worlds we live in, they also serve as heuristic devices—interpretive tools enabling advanced knowledge of a phenomenon or experience through the further development and reinterpretation of initial perceptions. A general understanding of how theories are built will be addressed and expanded upon in the subsequent chapters.

When a theory is built and deployed as a heuristic device, an abstract and internal sense of a person, place, event or thing may then be *further* ideated—or made visibly manifest—in the form of palpably remembered, written or otherwise recorded, and even physically embodied bits of knowledge. The theories stocking our shared warehouse of assorted ideas about the human experience are assembled into developmental bridges wherein each theory is made practical and practicable, further shaping our personal ontologies. An ontology is a rationale about the nature of one of the worlds we live in, containing propositions of what that world consists of and why. To characterize an ontology is to ask: "What is the nature of the 'knowable'? Or, what is the nature of 'reality'?" (Guba, 1990, p. 18). An important way to understand the *limits* of personal ontology is to think of it as a worldview, an acquired position that offers valuable perspectives of the human experience—while also obscuring some others.

For example, within a cause-and-effect worldview, theories are typically understood as partitioned from action. A cause-and-effect worldview

Heuristic Devices

Interpretive tools enabling deeper understanding of a phenomenon or experience through the further development and reinterpretation of initial perceptions.

Ontology

A particular worldview; a rationale about the nature of one of the worlds we live in, containing propositions of what that world consists of and why.

Worldview

An expressed orientation of an individual or group of people that describes their knowledge or point-of-view, understood to be an acquired position that offers valuable perspectives of the human experience—while also obscuring some others.

proceeds from the assumption that ideas are either linearly *derived* from action, or may be ultimately *converted* into action—but never the twain shall meet. However, within an ontology that supports the practice of arts-based research, *theory and praxis co-construct one another in an ongoing cycle of cause resulting in effect, and effect regenerating cause.* While this latter creative worldview values the creative work of the artist or designer in society, it is also a position and perspective that is alien to many scientific researchers. Providing a means to ameliorate this blind spot was one of the primary motivators in writing this text.

Foremost, this *Primer* aims to reveal how the arts lend themselves to *blended* spaces of naturalistic inquiry, aiding artists and scientists alike in their conduct of research. The arts and design fields occupy a paradigm where actions in or upon a target area or concern spawn emergent ideas even as the doing is enacted—and where ideas remain less than fully constituted until physically materialized or conceptually represented. Through the mediated interpretation of materials, languages, social contexts, or other data, "a way of experiencing...a particular cast of mind [is brought] out into the world of objects [and expressed ideas], where men [and women] can look at it" (Geertz, 1983, p. 99).

Creative Worldview

A creative worldview is an ontology that supports the practice of arts-based research, wherein theory and praxis are viewed as co-constructing one another in an ongoing cycle of cause resulting in effect, and effect regenerating cause. Understands works of art as works of research.

Paradigm

A body of beliefs and values, laws, and practices that govern a community of practitioners characterized by its success in representing the prevailing understandings, shared beliefs and research solutions of that community as a concisely defined worldview.

Objectives

The primary objective of this *Primer* is to dispel the notion that arts-based research is not research. Nothing could be farther from the truth. The scientific method is most useful for addressing hypothesis-based questions—guesses about what will happen given a particular set of controlled variables and ultimately requiring experimentation to collect replicable data as evidence that the hypothesis is true. Frankly, social science researchers face major limitations carrying the success of the scientific method within the physical sciences over to social

research since "persons are more difficult to understand, predict, and control than molecules" (Zeiger, n.d., para. 1).

What *is* fair to say is that arts-based research is *different* from scientific research, whether quantitative or qualitative, yielding distinct methodologies for knowing. John W. Creswell (1994) distinguishes between a research method as the means for "data collection and analysis," and research methodology "as the entire research process from problem identification to data analysis" (p. xvii). To characterize a methodology is to continually revisit the question: "How should the inquirer go about finding out knowledge?" (Guba, 1990, p. 18). A secondary objective of this *Primer* is to mark the distinctions of arts-based approaches to knowledge creation in the address of urgent questions about critical aspects of the human experience and our varying lifeworlds—in particular, those aspects that can neither be measured with exactitude nor generalized as universally applicable or meaningful in all contexts.

The worldview of a researcher—whether scientifically-based or arts-based—shapes the research inquiry at every level because it shapes a researcher's epistemological foundation. An epistemology is an ontologically situated point of view on what counts as knowledge and "truth," and is a strategy by which those beliefs may be justified (Strega, 2005, p. 201). To characterize an epistemology is to actively investigate: "What is the nature of the relationship between the knower (the inquirer) and the known (or knowable)?" (Guba, 1990, p. 18). Epistemologies constructed within an arts-based ontology, or worldview, tend to approach knowledge acquisition as occurring within a changing world where persons and phenomena do not always follow the rules. Research necessarily involves a researcher's intervention into that world—digging out connective elements, casting models, and constructing assemblies that shape the flux and chaos of each day's perceptions into a patterned reality we can comprehend and correlate.

Method

A specific means for data collection and analysis selected because of its appropriateness for addressing a particular kind of research question and its effectiveness in gathering a particular class of researchable data.

Methodology

A systematic approach to solving a problem; the entire research process from problem identification to data analysis.

Epistemology

An ontologically situated point of view on what counts as knowledge and "truth," and a strategy by which those beliefs may be justified.

In their sussing out of useful patterns to live by, arts practices and social science research practices have never been far afield. An arts-based research ontology accepts universal laws as they may emerge, yet it does not *presume* them and does not promote the validity of outcomes on their ability to be replicated without significant variance in other contexts. Rather, an arts-based ontology accepts a universe of variances and supports knowledge that presents itself as a local interpretation of reality, valid within its own context, yet fully subject to reinterpretation or translation into other contexts.

Ways of Knowing the World

The idea that scientific knowledge is *best* is a powerful story, but it is only one story of many that may be told about how humans have historically created, recorded, and extended knowledge. There are three working paradigms for addressing social, behavioral, and educational research problems: the qualitative descriptive domain, the quantitative classificatory and statistical domain, and the arts-based domain privileging hybrid empirical, interpretive, and naturalistic theory-building practices described by Lincoln and Guba (1985). The latter domain is the focus of this *Primer*. It is a domain governed by beliefs, values, laws, and practices different from the sciences, allowing a different character of research investigation that includes aesthetic "power and elegance, creativity, openness . . . independence . . . the [researcher's] emotional and intellectual commitment to the case itself, social courage, and egalitarianism" (Guba, 1990, p. 74).

It is important to note that not all arts practitioners are intending to build new theories through their research (although some arts praxis requires research, some arts praxis turns unexpectedly into research, and some arts praxis becomes the catalyst for future research). Some arts practitioners are seeking only to replicate prior patterns or theories, not

to invent anew. In other words, there *is* a legitimate difference between an avant-garde costume designer and a dressmaker content to customize previous designs rather than inventing new ones. So what distinguishes arts-based research as *theory-building* research practice, rather than pure artisanship, or the mere application of prior accumulated sociocultural knowledge stores? It must be understood that at its center, every research activity requires the surrounding of a research problem, and its key question, extending the discourse regarding that question toward the production and recording of new knowledge for a select community whose members also recognize the problem.

Concomitantly, each theory has its own hypothesis: a supposition about, or explanation of, the research question at its nucleus. The arts-based research problem accommodates various kinds of hypotheses from which to begin an inquiry: the kind of hypothesis that is reasoned deductively by deriving all possible conclusions that proceed from generally accepted laws about physical/material phenomena or broad assumptions about social behavior; the kind of hypothesis that is reasoned inductively by inferring some plausible conclusions from particular instances of physical/material phenomena or specific social behaviors; or the kind of hypothesis that is reasoned abductively by the discernment of likely conclusions from instinctual realms—including the unconscious and the imagination—through educated guesses about physical/material phenomena or social behaviors in the absence of complete evidence or full explanation.

A research hypothesis does not need to be complex at all, and can be as simple as the proposition, "This idea is important, worthy of extended conversation, and is hereby recorded for review." What makes any research relevant? The *most* relevant research requires that the question at the heart of the methodological activity be significant for the review of an audience of many, and not just an audience of the few, or of the one. Toward that simple end and

Hypothesis

A conjecture indicating a relationship between at least two variables, warranting further investigation that addresses the problem of explaining that relationship and what we may learn from it.

Deduction

Involves the deductive reasoning of a hypothesis, deriving all possible conclusions that proceed from generally accepted laws about physical/material phenomena or broad assumptions about social behavior.

Induction

Involves inductive reasoning of a hypothesis, inferring some plausible conclusions from particular instances of physical/material phenomena or specific social behaviors.

Abduction

Involves the abductive reasoning of a hypothesis, discerning likely conclusions through educated guesses about physical/material phenomena or social behaviors in the absence of complete evidence or full explanation.

throughout recorded history, the arts have been used to build theories about the natural world and as an avenue to address and explore some of the most significant questions of human existence within our complex of social worlds. It is research that has preceded the establishment of the sciences.

An Alternative Hypothesis: The Arts-Based Research Paradigm

Even in the most current scholarship attempting to explore arts-based research in education, the consensus of researchers is that "educational researchers are still trying precisely to define what we call arts-based educational research" (Taylor, Wilder, & Helms, 2007, p. 8). I suggest that a concise and effective characterization of a growing delta of research methodologies, "always in the process of creation" and demanding of "an understanding of incompleteness and uncertainty" (Springgay, 2002, p. 20), first requires a broad mapping of the contiguous terrain. Consequently, this *Primer* is intended to recognize and identify the opportunities afforded by arts-based research approaches to address questions differently than scientific research will allow (Leavy, 2009).

The greater the array of approaches in addressing a given set of substantive problems, the more successful a diverse community of research practitioners will be in surrounding those problems and generating a number of viable solutions. Just a quick scan of the qualitative and quantitative research paradigms recognizes that there are several approaches for addressing questions about social behavior in the natural world, and that certain practices are natively situated within theory-building paradigms that lend themselves to better addressing certain kinds of questions.

For example, the quantitative research paradigm is hewn and refined through "scientific investigation that includes both experiments and other system-

Quantitative Research
Measurements and classifications based on quantities and/or quantifiable data. Best at addressing questions through methods that yield mathematical expressions of constructs and relations, usually in terms of differences in degree.

atic methods that emphasize control and quantified measures" (Hoy, 2010, p. 1); this research paradigm is best at addressing questions through methods that yield mathematical expressions of constructs and relations, usually in terms of "differences in degree" (Sullivan, 2010, p. 58). Measurement in fact becomes paramount, and "in order for something to be measured, only its tangible [or, observable] aspects can be apprehended, and thus *the indices itself of a phenomenon become more important than the phenomenon*" (Giorgi, 1970, p. 291, emphasis added).

Qualitative Research

Identification of densely described distinctions based upon inferred characteristics or qualities of data. Best at addressing questions through methods that yield thick, rich descriptions, usually in terms of differences in kind.

The qualitative research paradigm is shaped and reshaped through the careful observation, documentation and revelation of things as they are, locating the common qualities of extraordinary situations and phenomena, and the "remarkable in everyday life" (Silverman, 2007, p. 23); this research paradigm is best at addressing questions through methods that yield thick, rich descriptions, usually in terms of "differences in kind" (Sullivan, 2010, p. 58).

Arts-Based Research (ABR)

The multisystemic application of interactive analytical, synthetic, critical-activist, or improvisatory creative cognitive processes and artistic practices toward theory-building. Best at addressing questions that can neither be measured with exactitude nor generalized as universally applicable or meaningful in all contexts. Stems directly from a researcher's artistic practice or creative worldview.

I will make the argument throughout the remainder of this textbook that the arts-based research paradigm is neither wholly quantitative nor qualitative, but instead carves out overlaps and burrows beneath both domains, thereby extending the array of questions researchers may address and the methods or terms they may use to explain them— enriching the gene pool of knowledge *in terms of differences in ways of knowing.* In order to better understand what an arts-based research paradigm yields in the address of substantive questions, this *Primer* begins with a "paradigm analysis" (Carroll, 1997; Rolling, 2009). A paradigm is defined as "a body of beliefs and values, laws, and practices which govern a community of practitioners" (Carroll, 1997, p. 171). An analysis of an arts-based paradigm for research allows it to be weighed effectively against other paradigms for theory-building and problem-solving.

Scientific historian Thomas S. Kuhn (1962/1996) postulated that paradigms develop because of their success in representing the prevailing understand-

Empirical-Analytic Art-making Model

Defines art as a system of production, a cause and effect intervention into a stock of empirical and manipulable elements, producing a stock of precious objects and forms, requiring a mastery over the techniques necessary to shape them.

Interpretive-Hermeneutic Art-making Model

Defines art as a system of communication, the expression of situated knowledge about a person's relationship with his or her social world, producing a stock of symbolic conveyances communicating the ways in which we experience the world and are sustained within it.

ings, shared beliefs and research solutions of a community of practitioners. However, when "new information cannot be integrated into the existing paradigm or when problems persist which cannot be resolved," a new paradigm is likely to arise to replace it (Carroll, 1997, p. 174). Kuhn's insight implies that even if the general (albeit irrelevant) question of what research practices work best in the development of the new knowledge continues to be asked, new methods will continue to arise or resurface, each worthy of fresh consideration. Hence, arts-based research methodologies are not analyzed here as an alternative to social science or experimental scientific methods, or merely to be contrarian; they are presented out of the recognition that we negotiate bodies of knowledge in a complex world where human beings build theories and life practices enacted along a full spectrum that includes both scientific *and* artistic systems for comprehending the human experience.

Harold Pearse (1983, 1992) has developed a framework for identifying the prevailing art-making systems (i.e., systems of *production, communication,* or *critical reflection*), which are often posed to work in opposition to one another. According to Pearse, an empirical-analytic art-making model defines art as *a system of production,* a cause and effect intervention into a stock of empirical and manipulable elements, a commodity-oriented process "that has as its basic intent a cognitive interest in the control of objects in the world" (Pearse, 1983, p. 159). Within this system, arts practices behave to produce a stock of precious objects and forms, requiring a mastery over the techniques necessary to shape them.

An interpretive-hermeneutic art-making model defines art as *a system of communication,* the expression of situated knowledge about a person's relationship with his or her social world (Pearse, 1983, p. 160). Within this system, arts practices behave to produce a stock of symbolic conveyances communicating "the ways in which we immediately experience an intimacy with the living world, attending to

its myriad textures, sounds, flavors, and gestures" (Cancienne & Snowber, 2003, p. 238).

A critical-theoretic art-making model draws upon critical theory literature and defines art as *a system of critical reflection*, a relativist and liberatory activity rendering invisible assumptions, values, and norms newly visible "in order to transform" and critique unjust social relations and empower marginalized individuals and communities within the arts practitioner's social world (Pearse, 1983, p. 161). Within this system, arts practices behave to alter the status quo.

The salient point here may already be obvious. There is no one single definition or conception of what art is, nor of what its effect upon the world is supposed to be. Consequently, neither is there one single artistic method for research. This crucial understanding of the arts-based research paradigm is aided by a thought experiment involving the important research concept of a "null hypothesis." In general, a hypothesis is a conjecture, a proposed answer to a research question. For the sake of argument, let us say the main question driving the writing of this *Primer* is: "What is art, and what kinds of knowledge does it aid researchers in acquiring?" A good research question "is a question of the relationship between variables" (Hoy, 2010, p. 67). A variable is any property of a researched subject, object, phenomenon, or event that can change, be changed or vary. Proposing a hypothesis—defined as *"a conjectural statement that indicates the relationship between at least two variables"* (Hoy, 2010, p. 68)—is thus a way of interrogating a question of the significance or magnitude of the connection between relatable properties in our experiential worlds. Conjecturing a succession of hypotheses, each presumed to be valid until new evidence is brought to bear, effectively guides a query about the systemic nature of experience toward a researchable solution.

At the initial stage of such research, a *null hypothesis* states there is no significant relationship between two variables except that which exists by

Critical-Theoretic Art-making Model

Defines art as a system of critical reflection, a relativist and liberatory activity rendering invisible assumptions, values, and norms newly visible in order to alter the status quo, as well as transform and critique unjust social relations.

Null Hypothesis

A hypothesis that is posed to be accepted or rejected in favor of an alternative hypothesis.

Variable

Any property of a researched subject, object, phenomenon, or event that can change, be changed, or vary.

Alternative Hypothesis
A hypothesis that succeeds the null hypothesis either as a negation or as variance from the original supposition as new evidence is brought to bear.

Formational Properties of Art
Manifested within an analytical approach to arts practice as an empirical mastery over the elements of, and the techniques for controlling, natural and manufactured mediums and materials.

chance; therefore, the null hypothesis to my main question is that there is *no* significant relationship between art or the creation and recording of new knowledge. The purpose of a null hypothesis is to provide a presumptive or default baseline standard of comparison held as true until evidence of an alternative hypothesis nullifies it. However, we never fully reject the null hypothesis as it may indeed ultimately be verified based on future evidence brought to bear; conversely, an alternative hypothesis is accepted in favor of the null only for as long as evidence supports its primacy as a solution. For example, an alternative hypothesis that might be conjectured in response to my proposed research question is: *Art is an analytical system for thinking and learning through observation, experience, and/or experiment, yielding the acquisition of knowledge characterized by its formational properties—manifested as an empirical mastery over the elements of, and the techniques for controlling, natural and manufactured mediums and materials.*

But while the suggestion of a relationship between "art as an analytic system" and the casting of experiential knowledge into knowable forms initially serves our thought experiment as an alternative hypothesis for an artistic method, like the variances in "the definition of art" from one individual to another, each conception of an artistic method is merely a place-holder for the next. Hence, what might be conceived as an alternative hypothesis from my relative point of view—to be proven more supportable through whatever evidence I might marshal—is nonetheless equivalent to a null hypothesis for another researcher who occupies an entirely different stance, perhaps viewing the initial proposed relationship between variables as a non sequitur. Ultimately, if there is no agreement on a common definition of either art or what constitutes knowledge, the baseline for comparison is also erased; the alternative hypothesis is effectively nullified.

For example, a substitute alternative hypothesis for conceiving the relationship between art and the

creation of new knowledge might be: *Art is a synthetic system for thinking and learning expressively, yielding the acquisition of knowledge characterized by its informational properties—manifested as self-expression, along with the invention, communication and reinterpretation of symbolic languages, cultural motifs and archetypal iconographies.* A third alternative hypothesis might be: *Art is a critical-activist system for thinking and learning through the interrogation of status quo social structures, yielding the interrogation of knowledge characterized by its transformational properties—manifested as a persistent iconoclasm, the will to stir up controversy and disrupt the accepted social order so as to redirect public attention, and an avant-garde fervor to change things as they are.* In any of these propositions, each alternative hypothesis is also equivalent to the null if, from another researcher's stance, the properties of the two variables as presented—the definition of art and its manifestation as research—are ontologically predetermined as having no relationship to one another.

That there are multiple realities and conflicting hypotheses for the significance of art in relation to research is entirely in keeping with a paradigm that proposes the *proliferation of alternative ways of knowing* over the *proving of certainties*. This distinction is not surprising given that arts-based inquiry is grounded in an ontology that recognizes arts practices as a twin peak alongside scientific practices on the landscape of human achievement. The facility of arts practices for altering the "methodological turf" of neighboring scientifically-based practices is an affinity that likely arises from a noteworthy historical peculiarity (Barone, 2006, p. 5). Renaissance thinkers who postulated a scientific method were drawing readily upon many arts-based empirical techniques successfully developed for the observation and documentation of our experience of light, shadow, the human anatomy, and the natural world. Then as now, arts-based methodologies "blur the boundaries between the arts and the sciences" (Cahnmann-Taylor, 2008, p. 3); they are proving to

Informational Properties of Art

Manifested within a synthetic approach to arts practice as self-expression, along with the invention, communication and reinterpretation of symbolic languages, cultural motifs and archetypal iconographies.

Transformational Properties of Art

Manifested within a critical-activist approach to arts practice as a persistent iconoclasm, the will to stir up controversy and disrupt the accepted social order so as to redirect public attention and change things as they are.

be adept at reshaping, eroding and shifting the foundations on either side of the qualitative-quantitative divide because they arguably belong to a paradigm from which the scientific first emerged.

Similar to William Pinar's effort to reconceptualize curriculum as "ongoing, if complicated conversation" more compatible to life and the constitution of knowledge in a postmodern society with a messy plurality of inaugurations and transactions of meaning (Pinar, 2004, p. 188), this *Primer* is intended to complicate our conceptions of research. A multi-modal array of artistic methods situated as a species of research effectively contradicts the assertion that research is solely a species of science. It also yields the alternative hypothesis that perhaps best serves as the tent pole for the remainder of this textbook's investigation: *Art is a reflexive system for thinking and learning improvisationally, yielding the acquisition of knowledge alternately exemplified by formational, informational, and transformational properties—manifested as a heterogeneous continuum of experiential learning possibilities.*

The Pre-History of Arts-based Research

Artistic methods for organizing and conveying new knowledge as valued forms, documented information, or social transformations predate scientific methods by millennia, likely dating back to Lower Paleolithic mark-making (Hodgson, 2000); artistic methods arguably became a rudimentary form of research at the moment early humans acquired the ability to reflect upon their marks so as to revisit or reinterpret prior meanings. I am using Wilson's (1997) framing of "*re-search*" practices as those which "search again, to take a closer second look" at that which offers "evidence about the way things were in the past, how they are presently, and even about how they might be in the future" (p. 1). This history of inquiry is shared commonly by both the Western world and all non-Western worlds, albeit differently.

From the Western point of view, it is instructive to take heed of John Henry's (2002) caution to avoid the assumption that the concept of "science" as we hold it today was the same held by those who contributed to what we identify as the "Scientific Revolution" in Western Europe (pp. 1-5). Instead, from the 14th to approximately the mid-19th century, the prevailing concept of inquiry was "something called 'natural philosophy', which aimed to describe and explain the entire system of the world" (Henry, 2002, p. 4). This study of the workings of nature and the physical universe was exemplified in the development of areas of inquiry such as chemistry, astronomy, physics, anatomy, botany, zoology, geology, and mineralogy.

Natural Philosophy
The prevailing concept of inquiry in the West from the 14th to approximately the mid-19th century. The study of the nature and the physical universe, considered to be a precursor to modern science.

Natural philosophy research practices were intended to harness the constituent elements and forces of nature and the universe through their categorization, measurement, and control—capturing them for humanity's benefit. This development of methods to control nature's constitutive elements and define the laws governing the natural world was analogous to the methods developed and technical skills applied in Renaissance visual arts, sculpture, and architecture (Berger, 1972). In this vein, as exemplified by artist-researchers like Leonardo Da Vinci, Western art-making served as "an instrument of knowledge" (Claude Lévi-Strauss quoted in Berger, 1972, p. 86), and an advertisement of the power of Western civilization to map and to mete out an ordered reality.

In non-Western worlds, art-making has also been an instrument of knowledge, whether making marks *upon* the world, making representational or symbolic models *of* the world, or making "special" aesthetic interventions that signal a person, object, artifact, action, event or phenomenon as uniquely valuable, sacred or life-sustaining—and thus *set apart* from the mundane and the ordinary within the world. The arts are how the members of every society and civilization render visual narratives of things cherished and tales oft-remembered;

through the arts we sing melody and verse of virtues celebrated and cautions warned; we dramatize and depict stories of meanings shared in common; we raise up heroes and cast down demons shaped in wood, stone, and clay; we write ourselves into histories and her-stories; we dance the unrestrained rhythm of our triumphs and sway beneath the weight of our tragedies; we dream of new possibilities in abstracts through the night.

In these ways, for time immemorial the arts have been employed as a practical means *to better inform* ourselves about the things that matter the most to us as a network of societies. In fact, the arts not only re-search the human experience, they enhance and reconstitute human information, refining the cargoes of meaning our collected data carries in tow. Hence, the arts have been the *precursor* to scientific, or logical positivist, research practices. The postpositivism of contemporary arts-based research is thus the reemergence of what may be termed *prepositivism*. This important idea will be elaborated further in this chapter.

Positivism
A philosophy of research establishing that hypothetical assertions can be positively verified through scientific data-gathering and quantifiable analysis.

Logical Positivism
A family of philosophies characterized by an extremely positive evaluation of science and scientific methods. Solves problems conjecturing hypotheses based within the limits of that which is already known.

The Recent History of Arts-based Research

Arts-based research methods and outcomes are rooted in diverse arts practices and arts-informed worldviews. Several authors have the distinction of being standard-bearers in the contemporary discourse on arts-based research. In *The Art and Science of Portraiture* (1997), sociologist Sara Lawrence-Lightfoot and arts educator Jessica Hoffman Davis boldly pioneered a vision for a qualitative research method "that blurs the boundaries of aesthetics and empiricism in an effort to capture the complexity, dynamics, and subtlety of human experience and organizational life" (p. xv).

In delineating the methodology they have named social science portraiture, Lawrence-Lightfoot and Davis (1997) begin with the compelling notion of creating "life drawings" of individual personalities

Social Science Portraiture
A qualitative research method pioneered by sociologist Sara Lawrence-Lightfoot and arts educator Jessica Hoffman Davis that integrates the systematic rigor and evocative resonance, blurring the boundaries between aesthetics and empiricism.

and organizational cultures that were as "probing, layered, and interpretive" as any artist's subject (p. 4). Yet their effort to define a method of research that integrates systematic rigor and evocative resonance is deliberately tempered by the caveat that artists and scientists must both continue to recognize "the limits of their media, their inability to capture and present the total reality" (Lawrence-Lightfoot & Davis, 1997, p. 5). Social science portraiture is also characterized by the intent to supersede the denseness and opacity of the walls within the corridors of academia by producing analyses and texts inviting dialogue about important public concerns, texts that are *contextualized* to speak to common folk who do not identify as researchers.

> Rather than viewing context as a source of distortion, [portraitists] see it as a resource for understanding. The narrative, then, is always embedded in a particular context, including physical settings, cultural rituals, norms, and values, and historical periods. The context is rich in cues about how the actors or subjects negotiate and understand their experience. (Lawrence-Lightfoot & Davis, 1997, p. 12)

Along with this adherence to context in research, portraiture also features a unique and admirable focus on illuminating evidence of the social benefit in the conduct of inquiry, noting that our view of our social world is easily distorted when in the all too common preoccupation with identifying social pathology, it "magnifies what is wrong and neglects evidence of promise and potential" (Lawrence-Lightfoot & Davis, 1997, p. 9). Nonetheless, the limits of social science portraiture as a method becomes apparent in the inherent murkiness of statements like: "In summary, portraiture is a method framed by the traditions and values of the phenomenological paradigm, sharing many of the techniques, standards, and goals of ethnography" (Lawrence-Lightfoot & Davis, 1997, p. 13). Phenomenology and ethnogra-

Phenomenology
A philosophy as well as a method of research into the understanding of "lived experiences," studying a small number of subjects through extensive and prolonged engagement.

Ethnography

A qualitative research method for the description of the customs of individual people and cultures, aiming to describe the nature of its subjects often through participant observation, interviews, and questionnaires.

Arts-Informed Research

Approaches to research informed by the aesthetic characteristics of works of art and/or design, artistic methods, or a specific artist but not stemming directly from a researcher's artistic practice or creative worldview.

phy are vastly different approaches for conducting qualitative research, and yet portraiture is supposedly a hybrid of both. This is difficult to comprehend. What is much easier to comprehend is that portraiture is either an arts-based or arts-informed research methodology, depending upon the period of immersion of the researcher.

Arts-informed research usually remains firmly rooted in the characteristics of the qualitative paradigm, but even the nomenclature of social science portraiture clearly overlaps the arts-based research paradigm. Arts-based research is a thoroughly practice-based approach to research and much more akin to a long-distance swim (Irwin & Springgay, 2008; Macleod & Holdridge, 2006); in contrast, arts-informed research is more like a free-dive. However, these free-dives are an important starting point for the retrieval of arts-derived forms and processes embedded throughout the sediment of our social structures, with the intent to infuse them into the scholarly work of creative and critical researchers (Knowles & Cole, 2008).

In fact, arts-informed research does not necessarily stem from a researcher's artistic practice or creative worldview at all, often reflecting instead a researcher who has been inspired by an artist, artistic methods, or the aesthetic significance of a body of artwork in their aim to represent their own qualitative research in a novel form or format (Eisner, 1997). Arts-informed research is distinguished from firmly practice-based research in that it is much more concerned with "how form accesses and shapes [research] content" than in building a research study upon the theoretical foundation of arts-based practice (Newton, 2005, p. 92). The commitment of a practice-based research methodology—whether in or of or through the arts—requires a sustained adherence to a creative worldview wherein works of art are *also* works of research, the dredging up of "processes, products, proclivities, and contexts" that support the activity of making art for scholarship's sake (Sullivan, 2010, p. 77).

In his book *Art Practice as Research: Inquiry in Visual Art*, Graeme Sullivan (2010) undertakes to break new ground by presenting a theoretical framework for understanding visual arts practice as research, arguing that the imaginative and intellectual work done by artists has a social significance that is "grossly undervalued" (p. xix). In Sullivan's view, the visual arts are a form of inquiry employing methodologies that stand apart from the social sciences except, notably, for the systematic and rigorous construction of knowledge both hold in common.

Sullivan's text is limited by its focus on the creation of new knowledge through *visual* means, focusing on the theories, practices, and contexts used by studio artists. Nevertheless, he has developed and diagramed a useful "Framework for Visual Arts Research" with braided domains of inquiry he outlines as: empiricist, or exploratory research methods and practices, with a substantive focus on producing social structures; interpretivist, or dialectical research methods and practices, with a substantive focus on facilitating social agency; and critical, or positional research methods and practices, with a substantive focus on instigating social action (Sullivan, 2010, p. 102).

While Sullivan cites his indebtedness to Jürgen Habermas (1971) for presenting empiricist, interpretivist, and critical ways of knowing as frames for constructing new knowledge about the world, these frames are also documented in other research literature (Alvesson & Sköldberg, 2000; Denzin & Lincoln, 1998; May, 2002). These frames also correspond to a framework by Canadian curriculum theorist Ted Aoki (1978)—who also draws upon Habermas—and are later elaborated by Harold Pearse (1983, 1992), who more specifically outlined the analogous *empirical-analytic*, *interpretive-hermeneutic*, and *critical-theoretic* domains of research method and practice described earlier in this chapter.

In Irwin and de Cosson's (2004) *A/r/tography: Rendering Self Through Arts-based Living Inquiry*, Rita Irwin shapes a research methodology out of the

Empiricist (Framework for Visual Arts Research)

Exploratory research methods and practices, with a substantive focus on producing social structures.

Interpretivist (Framework for Visual Arts Research)

Dialectical research methods and practices, with a substantive focus on facilitating social agency.

Critical (Framework for Visual Arts Research)

Positional research methods and practices, with a substantive focus on instigating social action.

A/r/tography
A research methodology conceived of as an interstitial space wherein definitions and understandings combining artist, researcher, and teacher practices are interrogated and ruptured in a critical exchange.

blended subjectivity of the artist, researcher, and teacher. Irwin (2004) defines a/r/tography as a creative analytic form of representation that privileges both text *and* image, and explains the appropriateness of the acronym a/r/t in the following terms:

Art is the visual reorganization of experience that renders complex the apparently simple or simplifies the apparently complex. Research is the enhancement of meaning revealed through ongoing interpretations of complex relationships that are continually created, recreated, and transformed. Teaching is performative knowing in meaningful relationships with learners. (Irwin, 2004, p. 31)

Following from this, a/r/tography as a methodology is conceived of as "an interstitial space" wherein definitions and understandings pertaining to art, research, and teaching are "interrogated and ruptured" in "a critical exchange that is reflective, responsive, and relational, which is continuously in a state of reconstruction and becoming something else altogether" (Irwin & Springgay, 2008, p. 106). Works of a/r/tography are intended to function as rhizomatic assemblages privileging the dynamics that are activated *"in-between"* when "meanings reside in the simultaneous use of language, images, materials, situations, space, and time" (Irwin & Springgay, 2008, p. 106).

The most obvious limitation of a/r/tography is that its conception as a singular although pluralistic methodology works to limit discourse on the variations of a larger arts-based research paradigm. A/r/tography does not attempt to accommodate or account for the many possible arts-based methodologies outside of itself. Even if it can transform into the "as yet unnamable" methodology (Derrida, 1978, p. 293), a/r/tography's discourse about arts-based research is insistently about a/r/tography at its nucleus. Ironically, for all its purported flexibility, a/r/tography often appears stuck on itself. What then is a researcher to do if a question demands the

inception of an arts-based research methodology other than a/r/tography, one that employs methods yet unnamed?

In her book *Method Meets Art: Arts-Based Research Practice*, Patricia Leavy (2009) attempts to introduce and present examples of six major genres of arts practice as research: narrative inquiry, poetry, music, performance, dance, and visual art. Leavy (2009) states her aim to bridge what she sees as the art/science divide, arguing that art and science "bear intrinsic similarities in their attempts to illuminate aspects of the human condition" (p. 2). Ultimately, Leavy's (2009) view is limited by a point of view that understands art-based methodologies not as part of a research paradigm unto itself, but merely as tools available to be "used by qualitative researchers across the disciplines during all phases of social research, including data collection, analysis, interpretation, and representation" (pp. 2-3). Most useful is Leavy's lending credence to the "hybrid, practice-based form of methodology" that is apt to be generated within the arts-based research paradigm (Sinner et al., 2006, p. 1224).

In *Arts-based Research in Education: Foundations for Practice*, edited by Melisa Cahnmann-Taylor and Richard Siegesmund (2008), the assembled authors outline various cases of literary, visual, and performing arts-based inquiry, practices which defined as "arts for scholarship's sake" (p. 1). Early in this text, Cahnmann-Taylor (2008) cautions that arts-based researchers have done little to legitimize their methods and approaches to inquiry by defining them "as an either-or proposition to more traditional, scientific research paradigms" (p. 4). A different quality of arts-based research practice stems from full immersion in an arts practice wherever its locus, since practices in the "literary, visual, and performing arts" each in their own way "offer ways to stretch a researcher's capacities for creativity and knowing" (Cahnmann-Taylor, 2008, p. 4).

The editors of this text also argue "against art as a separate, isolated form of human experience that

stands apart from how we understand and make sense of the world," highlighting arts practices as rational, structured inquiry (Siegesmund & Cahnmann-Taylor, 2008, p. 242). Like Leavy, they issue a call for hybridity in general research practices "that might include both scientific methods as well as arts-based methods" (Siegesmund & Cahnmann-Taylor, 2008, p. 232). The major limitation of their text is in not offering a flexible architecture for theory-building to guide researchers in structuring such hybrid pathways and models.

In their new book *Arts Based Research*, Tom Barone and Elliot Eisner (2012) preface their writing with the claim that the *term* arts-based research "originated at an educational event at Stanford University in 1993" (p. ix). This claim itself is the greatest limitation of this text given that the *concept* of arts-based inquiry or of studies of the human condition informed by aesthetic practices has arguably occupied a lead role in the generation of our stores of collective knowledge, both preceding and aiding the inception of the scientific revolution. Despite their dubious contemporization of age-old inquiry practices, Barone and Eisner do accurately identify the historical conundrum inherent in that "before the 18th-century period of the Enlightenment in the Western world, no substantial differences between the arts and sciences were recognized" (p. x)—a reference to the many centuries when natural philosophy investigations dominated the Western European effort to understand the universe. They also bring important light to a critical distortion regarding the empirical nature of research:

> As proponents and practitioners of arts based research, we find it ironic that what is regarded as empirical focuses upon studies in which numbers are used to convey meaning . . . It seems to us that, in general, we have our conceptions upside down. Indeed, it is interesting to note that the word *empirical* is rooted in the Greek word *empirikos*, which means experience. What is hard to experience is a

set of numbers. What is comparatively easy to experience is a set of qualities. (Barone & Eisner, 2012, p. xi, emphasis in original)

At base, Barone and Eisner's conception of arts-based research is encumbered by a limited definition of what art is and does, or how it may be applied in the service of knowledge. This compels me to disagree with Elliot Eisner's (2008) characterization of arts-based research as a "soft-form" of qualitative research (p. 19). The tendency to emphasize form over process, or to conflate the two, is a mischaracterization that stems from an empirical-analytic worldview that defines and delimits the conception of art primarily as a system for the *production* of expressed forms (Pearse, 1983).

Barone and Eisner devote a great deal of territory throughout their book to distinguishing between the non-discursive and emotive nature of the arts in contrast to the logical nature of the propositional discourse. But this is a mistake, trapping the definition of arts-based research into unnecessary confines, presented merely as a non-discursive means of representing qualitative research through the use of "pictures, or music, or dance, or all of those in combination" (Barone & Eisner, 2012, p. 1). The error in this conception is that art, or aesthetically derived meaning and knowledge, is in fact flexible enough to be alternately and alternatively discursive and/or non-discursive.

Upon closer examination, propositional claims that are understood to be either true or false are just as *representational* of important qualities of collective human experience as our most evocative expressions, those steeped in unutterable emotive characteristics. The arts can represent rigid truth claims; but they can also represent truth-stretching ambiguity. Any given arts practice typically possesses the flexibility *either* to build its theories linearly and logically, *or* to deftly and aesthetically indicate and adumbrate theories—in the latter case, leaving ample room for interpretation even as in-

herent qualities of reality, or "facts," are nonetheless represented. This flexibility identifies boundary lines for the arts-based research paradigm that flow beyond the qualitative social sciences.

Toward a Working Hypothesis of the ABR Paradigm

Many a researcher—especially those exploring qualitative or mixed methods representations of human experience in the natural world while eschewing wholly reductive, quantifying models—has stumbled unawares into this other paradigmatic world. The ABR paradigm has ten identifying characteristics that can be drawn out into the open by correlating ten fundamental ideas about arts-based research laid out by Barone and Eisner (2012) with several axioms and characteristics about naturalistic inquiry advanced by Lincoln and Guba (1985). Naturalistic inquiry is defined in contrast to logical positivism, "a family of philosophies characterized by an extremely positive evaluation of science and the scientific method" (Reese, 1980, p. 450). Positivist approaches to research seek to solve problems conjecturing hypotheses based "within the limits" of that which is "already known" (Sullivan, 2010, p. 31). Historically, outcomes of positivist inquiry have been "expressed as a difference in degree or quantity" in comparison "to other things we knew" (Sullivan, 2010, p. 31).

Naturalistic inquiry is presented as a postpositivist response to the inadequacy of positivism "in its application to the study of human behavior where the immense complexity of human nature and the elusive and intangible quality of social phenomena contrast strikingly with the order and regularity of the natural world" (Cohen, Manion, & Morrison, 2000, p. 9). Hence, naturalistic inquiry does not pretend to be a science, but is argued to serve as a means for *surrounding* research problems that demand elaborate descriptions, explanations,

Naturalistic Inquiry

A postpositivist response to the inadequacy of positivism toward understanding the immense complexity of variables in human nature and social behavior that demand rich descriptions, explanations, or ongoing critiques rather than true or false solutions.

Postpositivist (inquiry practice)

The study of the complex and intangible qualities of human behavior that accepts an ontology of realism and the utility of experimental methodology, but rejects the belief in absolute truths and unwavering adherence to objectivity.

or critiques rather than true or false solutions (Sullivan, 2010). I will extend this argument, proposing that whether or not ever before identified by name, the ten succeeding characteristics of naturalistic inquiry were also a prepositivist historical reality—evidence of social practices for the acquisition of knowledge that preceded the scientific method and which can now be redeemed to the general discourse on knowledge creation as intended through this *Primer's* discussion of arts-based research.

Prepositivist (inquiry practice)
Similar to postpositivism in construct, but pertaining to social practices for the acquisition of knowledge that preceded the scientific method.

The poststructural characteristic of the ABR paradigm understands our physical world as a common construction with as many ways to represent it as there are experiences of it, with each representative construction that attempts to model some constituent attribute in itself the casting of a whole new partially rendered world. Thus, the poststructurality of the ABR paradigm perceives "multiple constructed realities that can be studied holistically" given that they are intimately interconnected and each indicative of the larger shared human experience—even as these constructions each "inevitably diverge" in their representation of distinct points of view (Lincoln & Guba, 1985, p. 37). This aligns with Barone & Eisner's (2012) proposition that "Humans have invented a variety of forms of representation to describe and understand the world in as many ways as it can be represented" (p. 164).

Hence, all structures of meaning are arguably in flux, and all representation of meaning is ultimately adaptable. As a result, every ideation we embody and/or further signify, and every mark, model, or medium through which we represent or interpret aggregated knowledge is subject to further reinterpretation—even as social regularities, norms, and discursive provenances of meaning that are fortified to resist such reinterpretations likewise continue to emerge.

Poststructural
A characteristic of ABR wherein the understanding of our physical world is recognized as a common construction, with as many ways to represent it as there are experiences of it, with each representative construction casting a whole new partially rendered world.

Ideation
The visible manifestation of an initial theory, in the form of palpably remembered, written or otherwise recorded, and even physically embodied knowledge.

Reinterpretation
The continuing adaptation of every ideation we embody and/or further signify, and every mark, model, or medium through which we represent or interpret aggregated knowledge.

Postparadigmatic
A characteristic of ABR wherein earlier paradigms are not rejected or hierarchized but continue to exist as governing perspectives, available to be networked and drawn upon in the conduct of inquiry.

The postparadigmatic characteristic of the ABR paradigm reflects the postmodern and premodern condition wherein "earlier paradigms continue to exist as . . . governing perspectives for some people" (Pearse, 1992, p. 249). This is in contrast to the modern condition that gave rise to Eurocentric scientific philosophy and Occidental standard-bearing by rejecting the knowledge paradigms that governed other peoples as evidence of their being mere anthropological fodder—either Oriental, perceived as the remains of declining, subordinate, and annexable civilizations, or else "primitives," not yet fully people, and disposable (Nandy, 1983). This also aligns with Barone and Eisner's (2012) proposition that "Each form of representation imposes its own constraints and provides its own affordances" (p. 166).

Hence, no single knowledge paradigm is hierarchically preeminent, and all constructs across paradigms are networkable in the conduct of inquiry. The awareness of a plurality of knowledge paradigms coexisting within the ABR paradigm requires the adoption of a "naturalistic ontology" wherein assumed realities and knowledge constructs "cannot be understood in isolation from their contexts" and wherein it is understood that "contextual value structures are at least partly determinative of what will be found" by the inquiring researcher (Lincoln & Guba, 1985, p. 39).

Proliferative
A characteristic of ABR wherein inquiry generates turbulence, ambiguity, the miscegenation of categories, and an expanding discourse that proliferates possibility, variation, and multimodal understandings.

The proliferative characteristic of the ABR paradigm refers to when inquiry generates turbulence, ambiguity, the miscegenation of categories, and an *expanding* discourse that proliferates possibility, variation, and multimodal understandings. This aligns with Barone and Eisner's (2012) proposition that "The purpose of arts based research is to raise significant questions and engender conversations rather than to proffer final meaning" (p. 166).

Hence, the generation of an ongoing continuum of working hypotheses is favored over concluding an inquiry with a single context-free generalization

that no longer represents any particular case. Lee J. Cronbach (1975) has been touted for his argument of "a working hypothesis" as the ideal result of research (pp. 124-125). Lincoln and Guba cite Cronbach, noting "that there are always factors that are unique to the locale or series of events [being researched] that make it useless to try to generalize therefrom" (Lincoln & Guba, 1985, p. 123). Nevertheless, upon further reflection:

> ... inquirers *are* in a position to appreciate such factors and take them into account. And, as the inquirer moves from situation to situation, "his task is to describe and interpret the effect anew," that is, in terms of the uniqueness found in *each* new situation ... For, "when we give proper weight to local conditions, any generalization is a working hypothesis, not a conclusion." (Lincoln & Guba, 1985, pp. 123-124, quoting Cronbach, 1975)

Working Hypothesis

Akin to common practice within an artist's studio, a working hypothesis presupposes experiments and exploration that serve as either a prompt or a cue for engaging with new particulars in similar fashion.

Maintaining a working hypothesis is akin to common practice within an artist's studio, where experiments and exploration never quite conclude but typically serve as either a prompt or a cue for engaging with new particulars in similar fashion. In this way, theory is converted to practice *while* practice is converted to theory.

Prestructural

A characteristic of ABR wherein perception precedes measurement, a legitimization of the kinds of knowledge that are intuitive or felt; pertains to meanings and relationships not yet able or necessary to be quantified.

The prestructural characteristic of the ABR paradigm refers to the precedence of perception over measurement. Perception utilizes and legitimizes "tacit (intuitive, felt) knowledge" (Lincoln & Guba, 1985, p. 40). While perception inquires "what is the nature of this I sense?," measurement inquires "how much is there of this I sense?" Research questions pertaining to meanings and relationships not yet quantifiable or needful of measurement require methods "more adaptable to dealing with multiple (and less aggregatable) realities" (Lincoln & Guba, 1985, p. 40). This aligns with Barone and Eisner's (2012) proposition that "Arts based research can

capture meanings [and relationships] that measurement cannot" (p. 167).

Hence, the fullest perception of a subject, object, phenomena, or event being researched requires an appreciation of variable qualities and nuances acting in relationship—separate from or as a precursor to assigning numerical degrees of relationship. Prestructural meaning is the meaning that precedes any final "inscription of forms of representation," equally open to being sensed and interpreted through numbers, language, images, music—or even expressions of the physical body itself through drama, dance, and other forms of embodied performance (Siegesmund & Cahnmann-Taylor, 2008, p. 233). By the term prestructurality, I am referring to what "semioticians refer to as the experiential store" (Siegesmund & Cahnmann-Taylor, 2008, p. 233). John Dewey (1934/1989) recognized the bank of human experience as the site of felt, intuitive meaning in consciousness that is the precursor to symbolic thought (cited in Siegesmund & Cahnmann-Taylor, 2008, p. 233).

By legitimizing tacit knowledge exposing "more directly the nature of the transaction between investigator" and his or her initial percepts, ABR methodologies lend themselves to metacognitive study of the inquiry-shaping interaction between what we believe we know and the pre-symbolic abstracts of the world we first begin to perceive (Lincoln & Guba, 1985, p. 40).

Pluralistic

A characteristic of ABR wherein texts of idiosyncratic and common meaning are continuously negotiated, exchanged, reinterpreted, and blended in William James's oft-quoted "theater of simultaneous possibilities."

The pluralistic characteristic of the ABR paradigm refers to how texts of idiosyncratic and common meaning are continuously negotiated, exchanged, reinterpreted, and blended in William James's oft-quoted "theater of simultaneous possibilities" (1890/1952, p. 187). This aligns with Barone and Eisner's (2012) proposition that "As the methodology for the conduct of [social] research . . . expands, a greater array of aptitudes will encounter forms that are most suited to them" (p. 168).

Hence, "(e)very [wo]man is his [or her] own methodologist" (Mills, 1959, p. 123). In other words, there is plenty of room at the inn for the artist, the designer, the teacher, and the intrepid scientist in the conduct of ABR; all may bring their own tools to the workbench. By valuing the use of "him- or herself as well as other humans as the primary data-gathering instruments," the researcher properly recognizes that "all instruments are value-based and interact with local values but only the human is in a position to identify and take into account (to some extent) those resulting biases" (Lincoln & Guba, 1985, pp. 39-40).

Purposive

A characteristic of ABR wherein diverse arts practices exceed mere self-expression and are intentionally purposed to serve as important resources for the representative construction—or re-construction—of experience.

The purposive characteristic of the ABR paradigm makes apparent the ways in which diverse arts practices exceed mere self-expression and are purposed to serve as important tools "for describing and understanding the world or some aspect of it" (Barone & Eisner, 2012, p. 169). This aligns with Barone and Eisner's (2012) proposition that "For arts based research to advance, those who prepare researchers will need to diversify the development of skill among those who are being taught" (p. 169).

Hence, ABR methodologies tend towards inductive and abductive data analysis because these processes are more likely to identify and capture "the mutually shaping influences that interact" in those data (Lincoln & Guba, 1985, p. 40). Barone and Eisner foresee fruitful collaborations across university level education, communication, and arts departments in the preparation of cohorts of researchers to do the complex work of identifying what Lincoln and Guba (1985) qualify as the "multiple realities" represented in a set of data (p. 40).

Perspectival

A characteristic of ABR wherein no single perspective (or aggregate of perspectives) may ever be assumed to provide a complete view of the subject, object, phenomena, or event that is functioning as the site of an inquiry.

The perspectival characteristic of the ABR paradigm refers to the discernment that no single perspective (or aggregate of perspectives) may ever be assumed to provide a complete view of the subject, object, phenomena, or event that is functioning as the site

of an inquiry. Moreover, various and sometimes competing value systems—including the scientific—*are expected* to inform each perspective. This aligns with Barone and Eisner's (2012) proposition that "Arts based research is not only for arts educators or professional artists" (p. 169).

Hence, ABR methodologies acknowledge the absence of value-free inquiry through an active consideration of the interactivity of pluralistic and multiple perspectives and the values that inform them, especially their "resonance and dissonance" (Lincoln & Guba, 1985, p. 174). Ultimately, the ABR paradigm also welcomes qualitative and quantitative researchers into the fold because their values and perspectives carry shades of other realities not always shared or easily seen by arts educators or professional artists.

Particularizing

A characteristic of ABR wherein research findings are not generalizable or duplicable but are dependent upon the particular interaction between the investigator and the reality being represented.

The particularizing characteristic of the ABR paradigm captures and makes use of the ways in which research findings are "to some extent dependent upon the particular interaction between investigator and [the reality being represented] that may not be duplicated elsewhere" (Lincoln & Guba, 1985, p. 42). This aligns with Barone and Eisner's (2012) proposition that "In arts based research, generalizing from an *n* of 1 is an acceptable practice" (p. 170).

Hence, the particulars in the study of a single case are intended to yield a treasure trove for reflexive reporting and the construction of a series of hypotheses transferable to other sites of inquiry. In recent writing, Elliot Eisner (2006) points out how "in standard statistical studies, generalization is possible insofar as the sample selected from a population was random, which makes it possible to infer conditions or features to the population that are found in the sample, within, of course, some measure of probability" (p. 14). Eisner goes on to illuminate a notion that should be more obvious but is more often obscured under the strict governance of scientific and statistical data-gathering protocols:

But what do you do with an *n* of 1? Can generalizations be derived from a single case or from a narrative that has not been subject to quantification? My answer to those questions is "yes." What needs to be done is to think of generalization in a way that is quite different form its statistical parent. In fact we generalize all the time and have done so even before statistics became a refined inferential process. If you think about generalization in the way in which a great play—*Death of a Salesman*, for example—makes it possible for you to locate in the lives of others the travails that Willie Loman experienced as a traveling salesman, you get some sense of the ways in which an *n* of 1 can help you understand situations even though the initiating image was not statistically selected. (Eisner, 2006, pp. 14-15)

Single-Case Research Design

Case study research, wherein n = 1, geared toward the intensive study of an individual subject, object, phenomena, or event. The study of the multiple and variable particulars of a single case.

Ergo, the case study, or single-case research design, is argued to be an optimal mode of research, one that is "adapted to a description of the multiple realities encountered" at any given site of inquiry (Lincoln & Guba, 1985, p. 41).

Performative

A characteristic of ABR wherein the wide array of mediums and modalities through which we make and perform art also serve to supplement, to enlarge, to expand, and to diversify the tools available for researchers to use.

The performative characteristic of the ABR paradigm presents the wide array of mediums and modalities through which we make art, and raises to prominence the ways in which they also serve "to supplement, to enlarge, to expand, and to diversify" the tools available for researchers to use (Barone & Eisner, 2012, p. 170). This aligns well with the proposition that "The aim of arts based research is not to replace traditional research methods; it is to diversify the pantry of methods that researchers can use to address the problems they care about" (Barone & Eisner, 2012, p. 170).

Emergent (research design)

An approach to inquiry, wherein the researcher allows the research design to emerge or unfold into view rather than to construct it preordinately.

Hence, there is something improvisatory and unscripted about ABR methodologies, where the "method of discovery" in the wake of an inquiry is often just as significant a finding as any other outcome (Richardson, 1997, p. 88). Like a jazz performance, the performativity afforded within the ABR paradigm requires: firstly, an *emergent* approach to

Negotiated Outcomes (in research design)

An approach to inquiry, wherein the researcher prefers to negotiate meaning and interpretations with human sources, including the self, from which the data have been drawn.

Reconceptualized Criteria for Trustworthiness

Alternative concepts of validity and reliability in research, based not on universal replicability across all contexts but rather on the establishment of local credibility, transferability, dependability, and confirmability.

Patterning

A characteristic of ABR wherein theory is grounded in and built from its data and likewise responsive to its contextual values, composing an emergent formational, expressive, and/or critical aesthetic makeup.

Grounded Theory

A qualitative research method that appears to contradict the structure of traditional scientific methods, which begins with a hypothesis. Using this method, data collection is the first step toward analysis and theory building.

Pattern Model

A model for describing, explaining and interpreting the data utilized in identifying the relationships between variables within a system during the analysis and further exploration of individual, physical, or social experience.

inquiry, wherein the researcher allows the research design "to emerge (flow, cascade, unfold) rather than to construct it preordinately (a priori) because it is inconceivable that enough could be known ahead of time about the many multiple realities to devise the design adequately" (Lincoln & Guba, 1985, p. 41); secondly, *negotiated outcomes*, wherein the researcher "prefers to negotiate meaning and interpretations with the human sources [including the self] from which the data have chiefly been drawn because it is their constructions of reality that the inquirer seeks to reconstruct" (Lincoln & Guba, 1985, p. 41); and thirdly, *reconceptualized criteria for trustworthiness* of the research based on "the establishment of credibility, transferability, dependability, and confirmability" (Lincoln & Guba, 1985, pp. 289-331).

The patterning characteristic of the ABR paradigm allows substantive theory to be grounded in and built from its data set, while likewise holding responsive to its contextual values—composing an emergent aesthetic makeup that is *not* based primarily "on a priori generalizations" or theorizing (Lincoln & Guba, 1985, p. 41). This aligns with Barone and Eisner's (2012) proposition that "Utilizing the expressive [or formational, or critical, i.e., the aesthetic] properties of a medium is one of the primary ways in which arts based research contributes to human understanding" (p. 171).

Hence, a theory constructed within the ABR paradigm is "patterned; it is open-ended and can be extended indefinitely; and it is discovered empirically rather than expounded a priori" (Lincoln & Guba, 1985, p. 206). Allowing the site of inquiry to generate its own theoretical patterns draws upon the concept of grounded theory, "that is, theory that follows from data, rather than preceding them" (Lincoln & Guba, 1985, p. 204). Grounded theory is argued to develop a pattern model of the system of relations between variables present at a site of in-

quiry; in that model for describing, explaining and interpreting the data, "the pattern can be indefinitely filled in and extended: as we obtain more and more knowledge it continues to fall into place in this pattern, and the pattern itself has a place in a larger whole," namely, the social research landscape (Kaplan, 1964, pp. 159-160).

With this chapter's working hypothesis for an arts-based research paradigm positioned as context for all pursuant exposition, the subsequent chapters will aim to develop a flexible architecture for building theories that expand our collective base of research knowledge, each methodology featuring an artistic method of inquiry.

This first chapter has been presented as a preliminary introduction to the basic assertions and rationale for arts-based research practice and theory-building, necessitating a review of supporting literature more extensive than is typical for primers on more widely discussed research approaches.

Glossary

A/r/tography—A research methodology conceived of as an interstitial space wherein definitions and understandings combining artist, researcher, and teacher practices are interrogated and ruptured in a critical exchange.

Abduction—Involves the abductive reasoning of a hypothesis, discerning likely conclusions through educated guesses about physical/material phenomena or social behaviors in the absence of complete evidence or full explanation.

Alternative Hypothesis—A hypothesis that succeeds the null hypothesis either as a negation or as variance from the original supposition as new evidence is brought to bear.

Arts-Based Research (ABR)—The multisystemic application of interactive analytical, synthetic, critical-activist, or improvisatory creative cognitive processes and artistic practices toward theory-building. Best at addressing questions that can neither be measured with exactitude nor generalized as uni-

versally applicable or meaningful in all contexts. Stems directly from a researcher's artistic practice or creative worldview.

Arts-Informed Research—Approaches to research informed by the aesthetic characteristics of works of art and/or design, artistic methods, or a specific artist but not stemming directly from a researcher's artistic practice or creative worldview.

Creative Worldview—A creative worldview is an ontology that supports the practice of arts-based research, wherein *theory and praxis are viewed as co-constructing one another in an ongoing cycle of cause resulting in effect, and effect regenerating cause*. Understands works of art as works of research.

Critical (Framework for Visual Arts Research)—Positional research methods and practices, with a substantive focus on instigating social action.

Critical-Theoretic Art-making Model—Defines art as *a system of critical reflection*, a relativist and liberatory activity rendering invisible assumptions, values, and norms newly visible in order to alter the status quo, as well as transform and critique unjust social relations.

Critical Theory—A philosophical examination or critique of society and culture through the confrontation of dominant sociocultural systems or through the reinterpretation of literary texts and symbolic structures.

Deduction—Involves the deductive reasoning of a hypothesis, deriving all possible conclusions that proceed from generally accepted laws about physical/material phenomena or broad assumptions about social behavior.

Emergent (research design)—An approach to inquiry, wherein the researcher allows the research design to emerge or unfold into view rather than to construct it preordinately.

Empirical-Analytic Art-making Model—Defines art as *a system of production*, a cause and effect intervention into a stock of empirical and manipulable elements, producing a stock of precious objects and forms, requiring a mastery over the techniques necessary to shape them.

Empiricist (Framework for Visual Arts Research)—Exploratory research methods and practices, with a substantive focus on producing social structures.

Epistemology—An ontologically situated point of view on what counts as knowledge and "truth," and a strategy by which those beliefs may be justified.

Ethnography—A qualitative research method for the description of the customs of individual people and cultures, aiming to describe the nature of its subjects often through participant observation, interviews, and questionnaires.

Formational Properties of Art—Manifested within an analytical approach to arts practice as an empirical mastery over the elements of, and the techniques for controlling, natural and manufactured mediums and materials.

Grounded Theory—A qualitative research method that appears to contradict the structure of traditional scientific methods, which begins with a hypothesis. Using this method, data collection is the first step toward analysis and theory building.

Heuristic Devices—Interpretive tools enabling deeper understanding of a phenomenon or experience through the further development and reinterpretation of initial perceptions.

Hypothesis—A conjecture indicating a relationship between at least two variables, warranting further investigation that addresses the problem of explaining that relationship and what we may learn from it.

Ideation—The visible manifestation of an initial theory, in the form of palpably remembered, written or otherwise recorded, and even physically embodied knowledge.

Induction—Involves inductive reasoning of a hypothesis, inferring some plausible conclusions from particular instances of physical/material phenomena or specific social behaviors.

Informational Properties of Art—Manifested within a synthetic approach to arts practice as self-expression, along with the invention, communication and reinterpretation of symbolic languages, cultural motifs and archetypal iconographies.

Interpretive-Hermeneutic Art-making Model—Defines art as *a system of communication*, the expression of situated knowledge about a person's relationship with his or her social world, producing a stock of symbolic conveyances communicating the ways in which we experience the world and are sustained within it.

Interpretivist (Framework for Visual Arts Research)—Dialectical research methods and practices, with a substantive focus on facilitating social agency.

Logical Positivism—A family of philosophies characterized by an extremely positive evaluation of science and scientific

methods. Solves problems conjecturing hypotheses based within the limits of that which is already known.

Method—A specific means for data collection and analysis selected because of its appropriateness for addressing a particular kind of research question and its effectiveness in gathering a particular class of researchable data.

Methodology—A systematic approach to solving a problem; the entire research process from problem identification to data analysis.

Natural Philosophy—The prevailing concept of inquiry in the West from the 14th to approximately the mid-19th centuries. The study of the nature and the physical universe, considered to be a pre-cursor to modern science.

Naturalistic Inquiry—A postpositivist response to the inadequacy of positivism toward understanding the immense complexity of variables in human nature and social behavior that demand rich descriptions, explanations, or ongoing critiques rather than true or false solutions.

Negotiated Outcomes (in research design)—An approach to inquiry, wherein the researcher prefers to negotiate meaning and interpretations with human sources, including the self, from which the data have been drawn.

Null Hypothesis—A hypothesis that is posed to be accepted or rejected in favor of an alternative hypothesis.

Ontology—A particular worldview; a rationale about the nature of one of the worlds we live in, containing propositions of what that world consists of and why.

Paradigm—A body of beliefs and values, laws, and practices that govern a community of practitioners characterized by its success in representing the prevailing understandings, shared beliefs and research solutions of that community as a concisely defined worldview.

Particularizing—A characteristic of ABR wherein research findings are not generalizable or duplicable but are dependent upon the particular interaction between the investigator and the reality being represented.

Pattern Model—A model for describing, explaining and interpreting the data utilized in identifying the relationships between variables within a system during the analysis and further exploration of individual, physical, or social experience.

Patterning—A characteristic of ABR wherein theory is grounded in and built from its data and likewise responsive

to its contextual values, composing an emergent forma-
tional, expressive, and/or critical aesthetic makeup.

Performative—A characteristic of ABR wherein the wide
array of mediums and modalities through which we make
and perform art also serve to supplement, to enlarge, to
expand, and to diversify the tools available for researchers
to use.

Perspectival—A characteristic of ABR wherein no single per-
spective (or aggregate of perspectives) may ever be as-
sumed to provide a complete view of the subject, object,
phenomena, or event that is functioning as the site of an
inquiry.

Phenomenology—A philosophy as well as a method of re-
search into the understanding of "lived experiences,"
studying a small number of subjects through extensive and
prolonged engagement.

Pluralistic—A characteristic of ABR wherein texts of idiosyn-
cratic and common meaning are continuously negotiated,
exchanged, reinterpreted, and blended in William James's
oft-quoted "theater of simultaneous possibilities."

Positivism—A philosophy of research establishing that hypo-
thetical assertions can be positively verified through scien-
tific data-gathering and quantifiable analysis.

Postparadigmatic—A characteristic of ABR wherein earlier par-
adigms are not rejected or hierarchized but continue to
exist as governing perspectives, available to be networked
and drawn upon in the conduct of inquiry.

Postpositivist (inquiry practice)—The study of the complex
and intangible qualities of human behavior that accepts an
ontology of realism and the utility of experimental method-
ology, but rejects the belief in absolute truths and unwaver-
ing adherence to objectivity.

Poststructural—A characteristic of ABR wherein the under-
standing of our physical world is recognized as a common
construction, with as many ways to represent it as there are
experiences of it, with each representative construction
casting a whole new partially rendered world.

Praxis/*Prattein*—Praxis is the sum total of our moral and artistic
activities; the enactment, practice, embodiment, or realiza-
tion of our individual and collective contemplation and
speculation regarding the experience of social life within
the natural world.

Prepositivist (inquiry practice)—Similar to postpositivism in construct, but pertaining to social practices for the acquisition of knowledge that preceded the scientific method.

Prestructural—A characteristic of ABR wherein perception precedes measurement, a legitimization of the kinds of knowledge that are intuitive or felt; pertains to meanings and relationships not yet able or necessary to be quantified.

Proliferative—A characteristic of ABR wherein inquiry generates turbulence, ambiguity, the miscegenation of categories, and an *expanding* discourse that proliferates possibility, variation, and multimodal understandings.

Purposive—A characteristic of ABR wherein diverse arts practices exceed mere self-expression and are intentionally purposed to serve as important resources for the representative construction—or re-construction—of experience.

Qualitative Research—Identification of densely described distinctions based upon inferred characteristics or qualities of data. Best at addressing questions through methods that yield thick, rich descriptions, usually in terms of differences in kind.

Quantitative Research—Measurements and classifications based on quantities and/or quantifiable data. Best at addressing questions through methods that yield mathematical expressions of constructs and relations, usually in terms of differences in degree.

Reconceptualized Criteria for Trustworthiness—Alternative concepts of validity and reliability in research, based not on universal replicability across all contexts but rather on the establishment of local credibility, transferability, dependability, and confirmability.

Reinterpretation—The continuing adaptation of every ideation we embody and/or further signify, and every mark, model, or medium through which we represent or interpret aggregated knowledge.

Research (as Theory-Building Activity)—A researcher's intervention into a changing world where persons and phenomena do not always follow the prescribed rules—digging out connective elements, casting models, and constructing assemblies that shape the flux and chaos of each day's perceptions into a patterned reality we can comprehend and correlate.

Single-Case Research Design—Case study research, wherein $n = 1$, geared toward the intensive study of an individual

subject, object, phenomenon, or event. The study of the multiple and variable particulars of a single case.

Social Science Portraiture—A qualitative research method pioneered by sociologist Sara Lawrence-Lightfoot and arts educator Jessica Hoffman Davis that integrates the systematic rigor and evocative resonance, blurring the boundaries between aesthetics and empiricism.

Theory/*Theōria*—A representative construction—or re-construction—of a phenomenon of life shaped as a set of interrelated constructs represented in a distinguishable manner or form in order to describe, explain, and/or interpret the variables and variability of an experience within the world.

Transformational Properties of Art—Manifested within a critical-activist approach to arts practice as a persistent iconoclasm, the will to stir up controversy and disrupt the accepted social order so as to redirect public attention and change things as they are.

Variable—Any property of a researched subject, object, phenomenon, or event that can change, be changed, or vary.

Working Hypothesis—Akin to common practice within an artist's studio, a working hypothesis presupposes experiments and exploration that serve as either a prompt or a cue for engaging with new particulars in similar fashion.

Worldview—An expressed orientation of an individual or group of people that describes their knowledge or point-of-view, understood to be an acquired position that offers valuable perspectives of the human experience—while also obscuring some others.

A Flexible Theory-Building Architecture for Arts-Based Research

The Curious Case of Objectivity in Science-Based Research

The Scientific Method
Part of a powerful narrative mythology about the preeminent place of logical positivism and the Western mind in the pantheon of knowledge-making.

Few are fully aware that just as there is no single definition of art, there is *also* no *one* scientific method. The idea of "*the* scientific method" is part of a powerful narrative mythology about the preeminent place of logical positivism and the Western mind in the pantheon of knowledge-making—when the truth of the matter is that scientific practice is actually a wide body of methodological approaches developed over centuries, with many contributors from across the globe.

While the sciences seek to assign temporary certainties, the arts augur deeply into our enduring ambiguities, probing the unknown and aligning with patterns initially unseen. Consider for a moment the contrast between having a general understanding of the probable geological constitution of an undersea

rock lodged in a sandy shoal—and the realization that the rock you have been looking at is actually a cephalopod that has altered the color and texture of its skin to camouflage itself and appear as a meaningful part of its surroundings. Arts-based research methodologies—with their ability to perceive, decode, and reinterpret the disparate patterns of experiential knowledge in which we are all immersed—may be viewed as the cephalopods of research methods. Like the cephalopod, arts-based research methods maintain a flexible architecture for representing the world we live in, one grounded in the local site of inquiry. These methods can be characterized by their immense internal variability; it will be useful at the outset to contrast them with the more fixed characteristics of the scientific landscape.

My characterization of the rigidity of the scientific paradigm has to do with its own focus on providing a reliable, rules-based way of knowing and assessing the world, one that methodically seeks only to know "real things, whose characters are entirely independent of opinions about them," toward the "ultimate conclusion" of every man and woman about the nature of that thing being absolutely the same (Charles S. Peirce, cited in Buchler, 1955, p. 18). The selection of a scientific method for knowing the world is revealing, considering that there are certainly other methods to choose from.

For example, 19th century American philosopher Charles S. Peirce proposed four basic methods of knowing the world—(1) the method of tenacity wherein knowledge is fixed in place simply because the individual or community has habitually believed it to be true, holding tenaciously to their point of view even in the face of contesting opinions and evidence; (2) the method of authority wherein knowledge is authorized and disseminated by the ruling state, its institutions and experts, and is contested only when the powers that be are successfully ousted; (3) the method of intuition wherein knowledge is constructed through reasoning based not upon meticulous observations, but upon "truths"

Method of Tenacity

A way of knowing proposed by C. S. Peirce, wherein knowledge is fixed in place simply because the individual or community has habitually and tenaciously believed it to be true.

Method of Authority

A way of knowing proposed by C. S. Peirce, wherein knowledge is authorized and disseminated by the ruling state, its institutions and experts, and is contested only when the powers that be are successfully ousted.

Method of Intuition

A way of knowing proposed by C. S. Peirce, wherein knowledge is constructed through reasoning based not upon meticulous observations, but upon "truths" assumed to be self-evident by some even while yet invisible to others.

assumed to be self-evident by some, even while yet invisible to others; and finally, assumed to be most empirically rigorous, (4) the method of science.

Method of Science
A way of knowing proposed by C. S. Peirce, wherein knowledge is assumed to be most empirically rigorous.

Although at the end of this litany, scientific methods are clearly positioned by Peirce as the culmination of a hierarchy. However, Peirce also affixes the logical method of the scientist with an odd metaphor, likening it to a "bride" that has been selected from among others who also have their merits—a cherished lover that must be honored and championed above all others who are also worthy of honor in their own way (Charles S. Peirce, cited in Buchler, 1955, pp. 21–22).

Objectivity
The advocacy of disinterest and impartiality as an achievable methodological perspective when in the conduct of inquiry. The biased stance that scientific methods of inquiry are more impartial, unbiased and reliable than any other.

The bridegroom that partners with positivism at the center of scientific inquiry is the principle of objectivity. Strangely, this dyad generates a remarkable contradiction typically hidden in plain sight; it is illuminated in the following two quotes, cited in reverse order of appearance, from two successive paragraphs within the early pages of Wayne K. Hoy's (2010) *Quantitative Research in Education: A Primer.*

> We agree ... [that] an impersonal, disinterested, and external perspective is best captured in one word— objectivity. The ideal of *objectivity* coupled with rigorous and controlled empirical tests leads to dependable knowledge and promotes confidence in the outcomes. (Hoy, 2010, p. 3, emphasis in original)
>
> When using the scientific approach, no explanation is final, because a better one may be devised at any time; science is open. Nothing is irrevocably proved ... (Hoy, 2010, p. 2)

Highlighted here is a contradiction regarding the dependability and certainty of scientific outcomes, begging the question: If science is just as uncertain of its conclusions as any other way of knowing, is the assertion of scientifically-produced knowledge as the paragon of dependability truly an objective claim—or more like a proclamation of fidelity when one is in the thrall of a passionate love affair? Evidence from the ranks of scientific researchers has often suggested the latter (Spencer, 1866, pp. 93-94).

Ironically, the exclusive choice to know the world objectively is reflective of a researcher bias.

Hoy (2010) attempts to make the argument that while "some people may be more objective than others, *objectivity* as it is used . . . in science refers to the approach and method of science and not to the individual scientists themselves" (p. 4). This is a roundabout way of escaping the historical record that science has not yielded the overwhelmingly reliable conclusions traditionally claimed; nevertheless, Hoy goes on to contradict his own argument in the very next sentence when he describes science, accurately I would argue, as "a disinterested, impartial, and external perspective" (Hoy, 2010, p. 4). But methods do *not* have perspectives. Methods are inert; they are no more than tools. By definition, perspectives are attitudinal stances, or points of view. Only living, breathing, decision-making individual researchers and research communities are positioned to wield their tools of inquiry with a deliberate perspective toward their operation and purpose. Thus, Hoy reveals the wizard behind the curtain.

The stance that one's methods of inquiry are more impartial, unbiased and reliable than any other—when that stance itself is evidence of a supremely haughty bias—ultimately creates a tremendous blind spot. Stephen Jay Gould's (1981/1996) observation is worth quoting here, taken from his book *The Mismeasure of Man*:

> Science is rooted in creative interpretation. Numbers suggest, constrain, and refute; they do not, by themselves, specify the content of scientific theories. Theories are built upon the interpretation of numbers, and interpreters are often trapped by their own rhetoric. They believe in their own objectivity, and fail to discern the prejudice that leads them to one interpretation among many consistent with their numbers. (Gould, 1981/1996, p. 106)

Scientific practices are indicative of the bias to deduct and generalize rules explaining the natural

order of things through objective observation and experimentation so as to delineate a universal and causal reality—a "reality" that is abstracted from and independent of all compromising variables, taken as verifiable, stable, and replicable across all contexts. In contrast, arts practices are indicative of the bias to understand the multiple re-scriptings of experiential meaning constructed by differing observers to occupy any given local context, so as to more accurately represent our variable and contingent realities. Both biases are rooted in researcher predilections towards distinct yet overlapping methods of inquiry.

Such predispositions are also the reason why one researcher is biased to view a particular question to be of the most importance, co-opting research methods that best address that question as absolutely vital—while another researcher targets her focus on the kinds of questions that make those very same methods appear irrelevant. Like the bias of the left eye to see towards one periphery and of the right eye to see toward the other extreme, our scientific and artistic researcher biases work together simultaneously to produce a binocular vision and three-dimensional understanding of human life and its changing circumstances.

The Informative Nature of Art and Culture

Science has been defined as *"a dynamic process of experimentation and observation that produces an interconnected set of principles, which in turn generates further experimentation and observation and refinement"* (Hoy, 2010, p. 4, emphasis in original). Arts practices are no less dynamic, experimental, and deeply observed; they are organizing systems for the most human information of all—data impressed with social imperatives and emotional meaning. Uniquely, the arts serve as a means to better inform ourselves about the things that matter the most to us as local and global communities. Social information that is both wrought from and melded into

handmade and manufactured forms, cultural expressions, and transformational social critiques can also be viewed as richly complex hierarchies and networks of data. Arts-based methodologies constitute some of the most dynamic strategies at our disposal for the conservation, organization, and renewal of data that most effectively informs human beings of who we are, where we come from, what our purpose is, and where we may be going (Rolling, 2008a).

The arts are practiced to enhance human information—recalling and refining the cargoes of meaning our collected data carries in tow. Whether they are oral, visual, written or performance arts practices, arts-based methodologies for organizing human data effectively inform not because they are beautiful; rather, they are beautiful to us because they secure the coupling of our emotional attachments and enthrall our attention around the most salient qualities of life. This characteristic also makes them altogether effective at delivering their memetic cargo across the boundaries of language, through cultural divides and the passing years.

For example, the methodology by which Edvard Munch organized information about human suffering in paint on a canvas in *The Scream* (1893) was different than the methodology Käthe Kollwitz employed for organizing similar information in her drawings and etchings of *Woman with Dead Child* (1903), and different again from Alvin Ailey's methodology for organizing such information through his dance choreography surveying the African American experience in *Revelations* (1960). These particular works of art, like all elements of a culture or subculture, are constituted of raw data about human behavior in the natural world and represented as the result of being shaped by reflexive, inquiring, and informing methodologies.

Each culture is a complex pattern of social behaviors, systemized to sustain itself and the human agents, or methodologists, within it. A culture is formed in the coalescing of myriad independent

and decentralized individual choices; this amalgamation is typically self-organizing.

> Culture . . . is fast acting—the complex product of relatively rapid decisions and interventions. It is capable of superimposing patterns on the slow and ceaseless grind of nature the full consequences of which cannot be known in advance. (Wilson, 1998, p. 29)

Arts practices may therefore be defined as self-organizing behaviors through which humans construct and combine systems of meaning that employ material-specific, language-specific, and/or critical-activist methodologies, all with informational and larger cultural consequences (Rolling, 2008a).

If the basic aim of scientific research is "to find general explanations, called theories" (Hoy, 2010, p. 4), the basic aim of arts practices and arts-based research only expands the scope of inquiry; arts practices likewise yield ways to alternatively build, construct, and adapt "theories," or units of understanding, about human life and our experience in the world. However, arts-based theories are better understood as representations. That is, they *exceed* the ascribed certainty in any explanation, also expressing the as-yet-unexplainable and reinterpreting the too-easily-explained.

Each theory, in its own turn, describes, explains, attaches itself to, and/or deconstructs other prior theories of the world. Theories—as representations—ideate in mind and those ideas naturally cluster and self-organize into patterns. Arts-based theories are therefore reflexive tools for inquiry: sometimes they are best at representing their own internal coherence and utility as an understanding; sometimes they are best at representing the perceptive abilities of those who constructed them; sometimes they are best at representing their relationship to other theories; and sometimes they are best at representing an individual life or some collective experience of the world.

A work of art, design, architecture, film or literature is *also* a theory (i.e., a representation) of the world, and lends itself to being further theorized in works of arts-based research.

The Representative Tools of Arts-based Research Inquiry

Nineteenth-century American pragmatist philosopher and logician, Charles Sanders Peirce, presented a description of how signs function to produce meaning in cognition in this diagram of a semiotic triad, or triangle (See Figure 1).

Object

From 19th-century philosopher and logician, C. S. Peirce; the initial thing to which the sign or theory in the meaning-making process refers.

In Peirce's diagram, the object is the initial thing to which the sign or theory in the meaning-making process refers; it can be as physical as the human figure or as conceptual as particles or waves of light. The representamen is the mediating tool selected as an initial point of reference in an inquiry, one with some likely potential to validly re-construct that object in cognition—whether in the shape of a mark, a model, or some other aesthetic, qualitative, and/or quantitative signifier. A representamen might be a block of marble; or raw, unedited, unreflected-upon documents and observations of student learning; or a mathematical equation in the area of quantum physics.

Representamen

From 19th-century philosopher and logician, C. S. Peirce; the mediating tool selected as an initial point of reference in an inquiry, one with some likely potential to validly re-construct that object in cognition.

Once this initial mediating instrument is deployed, a dynamic meaning-making process is also

Figure 1

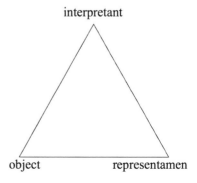

engaged—and depending upon the methodology used, the outcome of that inquiry process may alternatively be labeled a research outcome or a work of art. The meaning-making process is an internal discourse that decides what the prevailing understanding of the object of inquiry shall be. While this is certainly an iterative process that can be continued ad infinitum, one triangle of meaning crystallizing into a string of a thousand more, it is also a self-contained process that can either establish its own internal validity or find validity in its relation to similar inquiry processes.

In Peirce's now obscure terminology, the object and representamen must converge toward a sensible interpretant, which in turn may carry us over into a whole new round of inquiry about the nature of that object and, ultimately, the development of whole other systems of meaning for representing the object's significance. In other words, the covalent bonding between an object and representamen initiates the building of a working theory, with one or more interpretants employed along the way toward a meaningful rerepresentation of a phenomenon or experience within our world (See Figure 2). The outcome of inquiry might be Michelangelo's statue of *David*, or W. E. B. Du Bois' *The Souls of Black Folk*, or Einstein's theory of relativity—works of art and landmarks of literature represent theories just as effectively as mathematical equations. Each yields a reconstruction of lived or speculative experience.

Interpretant

From 19th-century philosopher and logician, C. S. Peirce; the convergence of object and representamen into meaningful sense.

Phenomenon

A fact or situation that is observed to exist or happen or the story of such an existence or happening. A phenomenon is considered to be a possible focus of inquiry.

Figure 2

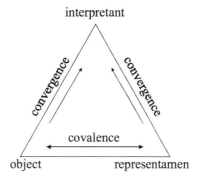

Figure 3

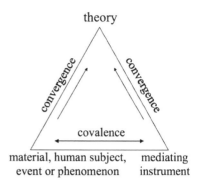

theory

convergence · convergence

covalence

material, human subject, event or phenomenon · mediating instrument

Natural or Manufactured Material

Any natural substance, product, or physical matter originating from plants, animals, or the earth—or else any synthesized product or fabricated apparatus derived from those natural materials that is a possible focus of inquiry.

Human Subject

A voluntary participant in ethically conducted research that presents the minimal possible risk, having first provided informed consent to the researcher. A human subject is considered to be a possible focus of inquiry.

Event

An occurrence that is happening or sharply localized at a place, or point in time. An event is considered to be a possible focus of inquiry.

Mediating Instrument

A tool of inquiry that mediates an understanding of its research focus.

Foci of Inquiry

Data analyzed through selected tools of inquiry.

Data

Natural materials, human subjects, phenomena, or events that become the focus of inquiry.

Tools of Inquiry

The selected mediating instruments of research theory-building.

By updating the language used by Peirce, we find a useful blueprint for understanding the theory-building process in an act of arts-based research. In the context of the general aim to describe, explain, and interpret a human life, the workings of nature, or the physical universe, we may substitute the term object with any category of natural or manufactured material, human subject, event, or phenomenon. Peirce's representamen can be substituted with terminology for any mediating instrument that has potential to be used as a tool of inquiry. As a tool of inquiry first mediates an understanding of its research focus, the dynamic convergence toward meaningful sense ultimately results in a theory that others may also see and understand (See Figure 3).

Theories are dormant and inert within a researcher's or artist's perception until they are communicated or otherwise conveyed—deposited into the common cultural store to prod further social inquiry. Another approach for updating Peirce's terminology is to view this meaning-making triad as the covalent bonding between selected foci of inquiry, or data, and compatible tools of inquiry, or mediating instruments, as each they interact and converge toward the building of a useful theory (See Figure 4).

Taken a step further, all research is representation, or theory-building—i.e., constructing representations of the realities and ideas that matter to the researcher, with each research act generating its own methodology and validity. An interpretive

Figure 4

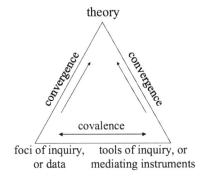

Covalence

The initial attraction and bond between the perceived properties of a natural material, event, or human subject phenomenon and the tool selected for mediating those properties, or rendering them more plainly.

Making Visible

A meaningful interpretation of a selected focus of inquiry, a process whereby the researcher envisages and shapes a methodology that allows for making sense of the collected data.

Making Sense

Simultaneous to making visible, the process of further shaping an ongoing discourse by comprehending the work done through the mediating instruments applied to a selected focus of inquiry.

strategy is inaugurated by the covalence between the perceived properties constituting a natural material, human subject, event or phenomenon and the tool of inquiry that mediates an initial understanding of those properties. During the work of making visible a meaningful interpretation of a chosen inquiry focal point, the researcher shapes a methodology. Simultaneously, during the work of making sense of a chosen inquiry focal point through applied mediating instruments, the researcher adds to and extends the prevailing discourse. In the back and forth between *making visible* and *making sense* (since not everything visible makes discursive sense, and not everything that makes sense is plainly visible), by the time the researcher or artist arrives at an emergent theory, their work has already established its own rigorously resolved internal validity (See Figure 5).

Figure 5

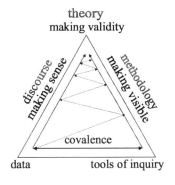

Figure 6

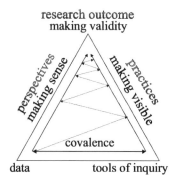

It is important to recognize that the work of the-ory-building is creative—both in the local sense and also in its contribution to culture and community. Theory-building activity constructs new knowledge and its own validity as either an artistic or research outcome. This activity also expands upon prevailing discourses—our theoretical *perspectives* on the creation of knowledge. In addition, the work of the-ory-building engineers the generation and expansion of methodologies, new theory-building *practices*, each one facilitating the creation of new representative knowledge (See Figure 6).

Interpretive Strategies: Starting Points for Works of Art and Research

Hominological
Pertaining to the interpretation and representation of human/social properties— including the uniquely human phenomenon of intentional, guided education.

Elizabeth Steiner (1988) lists three kinds of theories in educational and social research and sorts them into the following classes: "physical, biological, and hominological" (p. 13). Physical theories interpret and represent material/object properties and phenomena, biological theories interpret and represent living/ecosystemic properties and phenomena, and hominological theories interpret and represent human/social properties—including the uniquely human phenomenon of intentional, guided education. These classes of theory are *not* mutually exclusive, "since phenomena that can be given meaning as living phenomena also can be given meaning as

Figure 7

Question Type = Data Needed	Physical
	Biological
	Hominological

Physical Theory-building

Attempts to represent the characteristics and relations between physical materials/objects and associated living or human/social phenomena—it primarily requires data about things in natural and fabricated contexts.

Biological Theory-building

Attempts to represent the characteristics and relations between self-sustained living organisms/ecosystems and associated physical or human/social phenomena—it primarily requires data about living beings in their environments.

Hominological Theory-building

Attempts to represent the characteristics and relations between human beings and associated physical objects or living phenomena—it primarily requires data about homo sapiens in their behavioral, social, and psychological worlds.

physical phenomena, and phenomena that can be given meaning as human phenomena also can be given meaning as living and as physical phenomena" (Steiner, 1988, p. 13). Staking out a foundation slab for the theories we intend to build also designates the kinds of questions we will ask and the type of data we need to seek to begin an inquiry (See Figure 7).

A physical theory attempts to represent the characteristics and relations between physical materials/objects and associated living or human/social phenomena—it primarily views natural and fabricated objects and contexts as its data. Similarly, a biological theory attempts to represent the characteristics and relations between self-sustained living organisms/ecosystems and associated physical or human/social phenomena—it primarily requires data about living beings in their environments. Likewise, a hominological theory attempts to represent the characteristics and relations between human beings and associated physical objects or living phenomena—it primarily requires data about homo sapiens in their behavioral, social, and psychological worlds.

I propose that there are four interactive ways of processing new knowledge in an arts-based research (ABR) paradigm, both for theory-building and developing a methodological architecture. Like qualitative researchers, arts-based researchers focus on questions rendering deeply wrought and richly described understandings of human perception, social behavior, and the common qualities of our shared experience. However, arts-based researchers emphasize reflexive, aesthetic practice-based, and improvisatory methods for making meaning and recording knowledge. Thus, when a path of inquiry

Analytic (ABR Theoretical Model)

Involves thinking in a material, in shaped matter, formulated mediums, and curated artifacts and collections.

Synthetic (ABR Theoretical Model)

Involves thinking in a language, dialectically navigating shared symbolic and problem-solving systems.

Critical-Activist (ABR Theoretical Model)

Involves thinking through a context, critiquing prevailing circumstances, lifestyles unquestioned, contested ideologies, and ill-repeated events.

Improvisatory (ABR Theoretical Model)

Involves thinking reflexively, or idiosyncratically across analytic, synthetic, and critical-activist research architectures.

is engaged within an arts-based ontology, unique theoretical perspectives become available informing a way of thinking that will yield a meaningful outcome. Inquiry models must be compatible with the research question(s) and data source(s).

And like quantitative researchers, arts-based researchers are concerned with the generation of representative models that help us understand human social behavior, the natural world, and our place in it—but rather than a primary reliance upon mathematical or statistically expressed models, ABR theoretical models are alternatively: 1) analytic, which involves thinking in a material, in shaped matter, formulated mediums, and curated artifacts and collections; 2) synthetic, which involves thinking in a language, dialectically navigating shared symbolic and problem-solving systems; 3) critical-activist, which involves thinking through a context, critiquing prevailing circumstances, lifestyles unquestioned, contested ideologies, and ill-repeated events; and foremost, 4) improvisatory, which involves thinking reflexively, or idiosyncratically across all the aforementioned research architectures.

Theory-Building Practices for Doing Arts-based Research

Artistic Method of Research

A flexible mode of inquiry aimed at generating meaning-making systems and proliferating ABR theory-building practices that are either analytic and discipline-constrained, synthetic and interdisciplinary, critical-activist and trans-disciplinary, or improvisatory and post-disciplinary, absent of boundaries.

An artistic method of research is a *flexible* mode of inquiry, sometimes process-driven and sometimes product-driven—alternatively aimed at generating meaning-making systems and proliferating ABR theory-building practices that are either: analytic and discipline-constrained, operating within highly delineated boundaries of artistic tradition and technical norms in the making of meaning; synthetic and interdisciplinary, crossing boundaries of meaning-making practice; critical-activist and trans-disciplinary, disruptive of existing boundaries of meaning; or improvisatory and post-disciplinary, absent of boundaries. Theoretical perspectives yield theory-building practices, and those practices may be combined with

Figure 8

A Flexible Architecture for ABR		
Theoretical Perspective	*Analytic*	
Theory-building Practices	Logical	Empirical
Physical	PhL	PhE
Biological	BL	BE
Hominological	HL	HE

(Left axis label: Question Type)

compatible research question(s) and data source(s) to produce a flexible architecture for arts-based inquiry. The chart shown above depicts an analytic theoretical perspective; in it, the first letters of the question types and theory-building practices are combined for easy reference to inquiry approaches (See Figure 8).

To think in a material is an *a priori* analytic theoretical perspective that rigorously, empirically and/or formulaically extrapolates from trial and error knowledge of the preexisting properties of a natural or manufactured material, as well as from all preexisting canons of technical expertise for manipulating that same material by means of the various tools and mediums selected to interface with it. It yields both logical and empirical theory-building practices.

A flexible and analytic ABR architecture may yield either empirical outcomes that are rigorous and formulaic explorations of materials and associated ideas (See Figure 9), or more strictly logical outcomes that

Figure 9

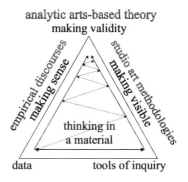

Figure 10

A Flexible Architecture for ABR						
Theoretical Perspective		*Synthetic*				
Theory-building Practices		Philosophical			Instrumental	
		Descriptive	Explanatory	Interpretive	Craft	Design
Physical		PhD	PhEx	PhInt	PhC	PhDes
Biological		BD	BEx	BInt	BC	BDes
Hominological		BH	HEx	HInt	HC	HDes

Question Type

are essentially syntactical explorations of media and techniques for manipulating material artifacts and arranging information visually.

Unlike analytic arts-based theory, synthetic theory "is not theory of form but of content" (Steiner, 1988, p. 19). To think in a language is either an *a priori* or an *a posteriori* synthetic theoretical perspective that navigates, communicates, and reinterprets prior and associative symbols, syntax, social quandaries, and dialogical needs to construct new personal and/or cultural meanings and common utilitarian solutions. It yields philosophical and instrumental theory-building practices (See Figure 10).

A flexible and synthetic ABR architecture may yield philosophical outcomes that are alternatively *descriptive, explanatory,* or *interpretive* (See Figure 10). The *a priori* nature of philosophical theory-building has been argued to be in its use of deductive reasoning to ascertain "essential properties and essential relations between properties" (Steiner, 1988, p. 20). The validity of *a priori* theory is argued to be attainable "by reason alone" (Steiner, 1988, p. 19); I would add that this reasoning process also ascertains properties and relations that are in flux and not quite so certain.

On the other hand, the *a posteriori* nature of instrumental theories builds interpretive research outcomes "contingent" upon a validity that is only "ascertainable by experience" (Steiner, 1988, p. 19). Thus, a synthetic inquiry architecture may also yield either an artisan's *craft-based* outcomes of utilitarian or embellishing value, or correspondingly, a

Philosophical

An a priori ABR theory-building practice, proceeding from prior theories and understandings, and derived from a synthetic theoretical perspective.

Instrumental

An *a posteriori* ABR theory-building practice, proceeding from observations and experiences in hindsight, and derived from a synthetic theoretical perspective.

Figure 11

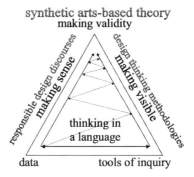

designer's *applied* outcomes exemplifying a problem-solving value while serving as a natural berth for scientific and educational research collaborations and connections (See Figure 11).

To think through a context is an *a posteriori* critical-activist theoretical perspective that actively critiques the prevailing matrices and archaeologies of our social structures so as to more beneficially reconfigure them. It yields interrogative research outcomes (See Figure 12).

In the interrogation of our lifeworlds, an artistic method addresses questions attending to the socially constructed aspects of knowledge, accounting for phenomena that are just as much a fact of life as any other and just as accessible to study, albeit not subject to definitive measurements.

A flexible and critical-activist ABR architecture works to interrogate and reinterpret discourses that

Interrogative

An *a posteriori* ABR theory-building practice, proceeding from observations and experiences in hindsight, and derived from a critical-activist theoretical perspective.

Figure 12

A Flexible Architecture for ABR		
Theoretical Perspective	*Critical-Activist*	
Theory-building Practices	Interrogative	
Physical	PhI	
Biological	BI	
Hominological	HI	

Question Type

Figure 13

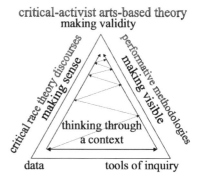

contextualize our lives through problematic social constructions that dominate, delimit, and distort perceptions of our local contexts as though they were entirely "manifest, nameable, and describable" (Foucault, 1972, p. 41). Such interrogations first identify a matrix of socially accepted, normalizing narrative "regularities" with the aim of *reconstructing* and *re-presenting* them; next, as guided by a relativist, situational and/or transgressive aesthetics, they alter and disrupt socially accepted narratives through the *montaged, collaged,* or *bricolaged* juxtaposition of reconsidered ideas, materials, media, or methods; finally, they *rescript* lived and local contexts, introducing a theater of multiple selves and simultaneous possibilities as the groundwork for newly inaugurated complexities of identity (See Figure 13).

To think reflexively is an improvisatory theoretical perspective that exercises continuous, practice-

Figure 14

A Flexible Architecture for ABR			
	Theoretical Perspective	*Improvisatory*	
	Theory-building Practices	**Reflexive**	**Ad Hoc**
		Intuitive	Transient
Question Type	Physical	Combinatory	
	Biological	Combinatory	
	Hominological	Combinatory	

Ad Hoc

An improvisatory ABR research outcome generated, arranged and concluded for a particular purpose or problem that is not generalizable and not designed for use in other situations.

based experiential learning wherein "(e)very [wo]man is his [or her] own methodologist" (Mills, 1959, p. 123). It yields *reflexive* and/or *ad hoc* research outcomes, allowing for intuitive and/or transient ways of knowing that may combine methods across the greater architecture of the ABR research paradigm (See Figure 14).

A flexible and improvisatory ABR architecture spawns *emergent* methodologies (See Figure 15). Art-making behavior ranges from the purely instinctual and unconscious, to the fully cognitive. Between these two distinct ways of knowing lies the intuitive—defined as that "which allows us to escape the inflexible world of instinct by mixing unlike entities," relying neither solely on inexplicable precognitive impulses or careful logic but on that which is often wholly and simultaneously "inventive and unreasonable" (Wilson, 1998, p. 31).

The utility of an improvisatory arts-based research architecture should be obvious. Not everything that is knowable or worthy of knowing in human social worlds can be captured adequately within mathematical or statistical frameworks and scientific theoretical orthodoxies. Nor is everything that is knowable or worthy of knowing a permanent fixture in the worlds we live in. Some knowledge is ephemeral and becomes obsolete or unusable in its original forms. In fact, there are so many kinds of knowledge, it is no surprise that some of it is *best* conveyed artistically—through accumulated marks,

Figure 15

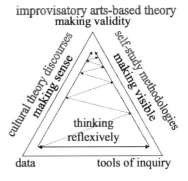

aesthetic models, and special, even transitory, interventions. Sometimes the purpose of art is to record and preserve knowledge over time. Sometimes the purpose of art is to raise questions about the knowledge passed down to us, contesting time-tested certainties. But whatever the purpose, art always forms, informs, and/or transforms ideas.

Whether in the making of art products or art as research, the dynamics of Peirce's semiotic triad renders the divide between the representational and the abstract as moot. Representational outcomes and abstract outcomes are *both* mediations of experience. Every representation presents a useful abstraction of human/social/natural experience, and every abstraction of human/social/natural experience stands in as a useful representation of the same. Representational outcomes and abstract outcomes *both* mediate the known world in order to present a theoretical interpretation of that world. In other words, *theory* (T) equals *experience* (E) first engaged and then further mediated by one or more material, symbolic, or performed *interpretants* (I)—whether that experience is lived, acquired, or negotiated in the form of extant discourses. This may also be written as the ABR theory-building algorithm: $T = E \div I$.

Each ABR inquiry architecture also yields linkage points that may be woven together with strongly aligned qualitative and quantitative research methods into hybrid methodologies addressing a research question and data set. In the remaining chapters of this book, I will look dialogically at brief overviews of the work of various researchers as they take pioneering steps engaging in analytic, synthetic, critical-activist, and improvisatory approaches to arts-based inquiry. I offer evidence of laden possibilities for scientists to cross over into arts-based domains of understanding and for artists to cross borders into scientific territories in their pursuit of knowledge. I am suggesting a free-for-all in the creation of new knowledge, one far more advantageous than previously acknowledged.

Implications for Writing Research

At the conclusion of each of the ensuing chapters, this textbook will consider the implications of applying that arts-based methodology to the writing of research papers. Perhaps the greatest benefit in exploring the arts-based research paradigm in research writing is in overcoming the biases inherent in scientific research writing. The need for *blended* spaces of inquiry, which draw upon divergent pathways for illuminating reality and overcome inherent biases limiting our best understandings, may be simply and visually demonstrated.

Waggle a fingertip directly in front of one of your eyes, almost brushing the eyelashes, while the other eye is held shut. Next, keep waggling your finger, yet close the eye you had originally been waggling the finger in front of while at the same time opening the eye without the finger in front of it. Finally, keep waggling your finger and open both eyes at the same time. One eye was telling the story of a waggling object—one too close for comfort, dangerously eclipsing one's vision. This was a partial understanding. At the same time, the other eye told of no impediment to sight whatsoever, also a partial understanding. Yet with both eyes open, the two sources of information *blended* in cognition to create the fuller understanding that there was just a finger waggling in front of one's left or right eye, but not the other.

While this is a simple spatial story, the cognitive ability to blend information pathways into understanding remains intact even as the sources of inquiry multiply in number, or the information they supply increases in complexity. Further, the increase and blending of new saliencies and their multiple, polyphonic, and divergent sources constitutes a praxis that promises the proliferation of remarkably anomalous theory outcomes and trajectories of understanding. All individuals expand their present stock of ideas through independent choices actively assimilating new concepts—making sense of the

Polyphony

Multiple voices working independently yet creating a single texture of contrasts that work together in counterpoint.

new in relation to the known. This has proven vital to the development of our species as the most monumental and enduring learning achievements involve a process that best constructs a compatible fit for anomalous new components into preexisting patterns of thinking. Echoing this cognitive artisanship, the best research papers blend the artful with the scientific, making the new as an outcome of the known. Good arts-based research writers must manage to do the following:

- State the research problem and identify a researchable question at its core.
- Introduce the reader to your point of view on why the problem has attracted your interest.
- State your initial claims, surveying and describing your arts-based approach to the problem and why that approach lends itself to a deeper understanding of the issues at hand.
- Begin building your theory, revealing evidence of how you are *making sense* of the prevailing discourse(s) about that type of question while simultaneously *making visible* your process of representing its meaningfulness to you. Provide evidence of analytical, synthetic, critical-activist, or improvisatory theory-building to support each of your claims. Make your own contributions to emergent understandings explicit—these contributions help constitute your methodology.
- Convey your current conclusions as a theory-in-progress, a representation of your experience with an initial set of data, mediated so as to interpret its meaningfulness.

Implications of Arts & Design Practices in Curriculum-making and Learning

The promotion of the arts in education is critical toward also promoting a fuller understanding of the importance of arts practices in *learning*. In a diacrit-

ical fashion—like that of a calligraphic stroke of black ink on rice paper that takes the shape of a flower petal or a single accent over the letter 'é' and alerts the reader to interpret the referential symbol differently than usual—I argue that we take this opportunity to rethink the purpose of the arts in curriculum, as well as the nature of curriculum itself.

Curriculum-making

An arts-based approach to making curriculum.

Sometimes it is better not to meet a problem head on. Richard S. Prawat (1999) described a problem that has vexed educators and learning theorists for years, a problem that has been termed as the learning paradox. The paradox attempts to address how it is that new and more sophisticated knowledge might be fashioned out of prior, less complex knowledge. In response, educators have generally sought to construct curriculum enterprises as if they were efficient and plumb aligned prefabricated architectural structures. This is evident in the language that asks teachers to develop "the conceptual foundations to frame and shape curriculum content and to align instruction and assessment tasks" (Stewart & Walker, 2005, p. 18).

While it is a fascinating pretense to suggest that across the nation, at any given grade-level, all children arrive at the same curricular destination at the same time during the same testing period, we should not kid ourselves. Our curriculum plans and outcomes do not construct minds; students figure themselves out. They will do so whether teachers help them or not. Moreover, "students learn both more and less than they are taught" (Eisner, 2002, p. 70). They take away from our best-laid curriculum plans only what they need, and only what they choose to. Life and experience writes its own curriculum, differently for each student, yet always in some way brought into intersection with the learner's daily schooling experience; life and daily activity does not adhere to the lesson plans educators write before the students' arrival.

Like the exercise of freehand drawing, learning tends to migrate artfully around the constraints of predictability and measurement. The possibilities

for learning are not pre-scripted; they are emergent. According to website information provided on the curriculum of an independent school in Vancouver, Washington, a curriculum may be considered emergent if it evolves in response to the initiatives and decisions undertaken by both adults and children, "diverging along new paths as choices and connections are made," remaining "open to new possibilities that were not thought of during the initial planning process" (The Gardner School, 2006).

I have written about an exercise in curriculum-making that took place at The School at Columbia University as my 4th grade students responded to a field trip to view the installation of The Gates in New York's Central Park in the winter of 2005, a uniquely collaborative work of conceptual art by artists Christo and Jeanne-Claude (Rolling, 2006b). In the article, I described how the development of student responses over several weeks surreptitiously afforded each participant in this curriculum experience with the open space to conceptualize and visualize some of the meanings most salient to his or her thinking.

> I offered the opportunity to build our own gateways; classroom conversations began to proliferate *ad hoc* gateways of understanding in the form of imagined stories surrounding our handmade gateways; the learning possibilities I [originally] had in mind altered to include story craft, writing, and editing in the art studio as a way of revealing the ideas about gates the students were acquiring through their engagement with materials. (Rolling, 2006b, p. 42)

Curriculum took on a life of its own as students were allowed to learn what they wanted to learn, each following his or her own grain. In the end, every student wrote a story about their construction and its significance. Some students made bridges rather than gates. Some students locked and barricaded their gates as part of an imagined emperor's fortress wall. Some constructed not only

a portal, but also the fantastic land on the other side. One student found in his materials a piece of wood that reminded him of a large proscenium arch, so he pronounced that he would make a movie theater rather than a gateway. Allowed to go his own way, this student built his theater with exacting detail and symmetrical zeal. His approach to the project suggests an unconventional response to the purported learning paradox: new knowledge is fashioned *in relation* to prior and oftentimes ancillary areas of knowledge.

Prior knowledge is never fully transcended by new experience; prior understandings coexist, connect and are co-opted within emerging development. New stories do not replace old stories; new meaning merely overlays the old in an archaeological accrual of understandings. Hence, no practice for making art of life should be misconstrued as an epistemological or ontological appendix to the scientific knowledge project, nor as a curio best viewed in museum casings or behind velvet ropes, nor as some vestige of an obsolete evolutionary imperative, nor as the unchecked metastasis of an anomalous human behavioral tic. Rather, arts-based learning is what lies beneath each of us in common—supporting our sense of who we are and what we know. Arts-based learning outcomes are ways in which we interpret and more tangibly understand the qualities of our experience within the natural world, and our identities as they are formed, informed, and transformed by that experience.

As an arts practitioner and a teacher of art, I must continue to question the absolute ends that often accompany progressive enterprises in education. We reduce curricular possibilities and learning outcomes rather than proliferate them, fearing the loss of control of those learning outcomes, fearing the loss of control of our students. We postulate curricular designs that will yield enduring understandings when, in life, understandings often erode, usually evolve, and inevitably change. In fact, this is as it must be since—as in the ecological cycle of life—the

new stuff of knowledge must always raid the old stuff for its nutrients in order to sustain itself and grow. In life, there is very little, if anything, that endures.

Given that humans construct systems of meaning utilizing material-specific, language-specific, and/or critical-activist methodologies, these same systems are also useful strategies for learning. A system is defined as a "set of elements or parts that is coherently organized and interconnected in a pattern or structure" that becomes more than the sum of its parts and "produces a characteristic set of behaviors" classified as its "function" or "purpose" (Meadows, 2008, p. 188). I argue that art-making generates and perpetuates systems of thinking and learning that have long proven to be "significant in the evolution of the species" and thus "remains significant in the development of the individual," especially in our ability to influence mutually advantageous behavior in one another (Wilson, 1998, p. 31).

These systems involve thinking and learning analytically through observation, experience, and/or experimentation, building new forms of material and procedural knowledge; thinking and learning synthetically, expressing new information about current and often invisible knowledge; thinking and learning critically, actively transforming prior knowledge contexts; and thinking and learning improvisationally, reincarnating past and present knowledge into the shape of future questions. Curriculum resources and pedagogical strategies will be outlined at the conclusion of the remaining chapters exemplifying each of these art-making systems, expanding upon some basic understandings proposed by Graeme Sullivan (2010).

Glossary

Ad Hoc—An improvisatory ABR research outcome generated, arranged and concluded for a particular purpose or problem that is not generalizable and not designed for use in other situations.

Analytic (ABR Theoretical Model)—Involves thinking in a material, in shaped matter, formulated mediums, and curated artifacts and collections.

Artistic Method of Research—A *flexible* mode of inquiry aimed at generating meaning-making systems and proliferating ABR theory-building practices that are either analytic and discipline-constrained, synthetic and interdisciplinary, critical-activist and trans-disciplinary, or improvisatory and post-disciplinary, absent of boundaries.

Biological Theory-building—Attempts to represent the characteristics and relations between self-sustained living organisms/ecosystems and associated physical or human/social phenomena—it primarily requires data about living beings in their environments.

Covalence—The initial attraction and bond between the perceived properties of a natural material, event, or human subject phenomenon and the tool selected for mediating those properties, or rendering them more plainly.

Critical-Activist (ABR Theoretical Model)—Involves thinking through a context, critiquing prevailing circumstances, lifestyles unquestioned, contested ideologies, and ill-repeated events.

Curriculum-making—An arts-based approach to making curriculum.

Data—Natural materials, human subjects, phenomena, or events that become the focus of inquiry.

Event—An occurrence that is happening or sharply localized at a place, or point in time. An event is considered to be a possible focus of inquiry.

Foci of Inquiry—Data analyzed through selected tools of inquiry.

Hominological—Pertaining to the interpretation and representation of human/social properties—including the uniquely human phenomenon of intentional, guided education.

Hominological Theory-building—Attempts to represent the characteristics and relations between human beings and associated physical objects or living phenomena—it primarily requires data about homo sapiens in their behavioral, social, and psychological worlds.

Human Subject—A voluntary participant in ethically conducted research that presents the minimal possible risk, having first

provided informed consent to the researcher. A human subject is considered to be a possible focus of inquiry.

Improvisatory (ABR Theoretical Model)—Involves thinking reflexively, or idiosyncratically across analytic, synthetic, and critical-activist research architectures.

Instrumental—An *a posteriori* ABR theory-building practice, proceeding from observations and experiences in hindsight, and derived from a synthetic theoretical perspective.

Interpretant—From 19th-century philosopher and logician, C. S. Peirce; the convergence of object and representamen into meaningful sense.

Interrogative—An *a posteriori* ABR theory-building practice, proceeding from observations and experiences in hindsight, and derived from a critical-activist theoretical perspective.

Making Sense—Simultaneous to *making visible*, the process of further shaping an ongoing discourse by comprehending the work done through the mediating instruments applied to a selected focus of inquiry.

Making Visible—A meaningful interpretation of a selected focus of inquiry, a process whereby the researcher envisages and shapes a methodology that allows for *making sense* of the collected data.

Mediating Instrument—A tool of inquiry that mediates an understanding of its research focus.

Method of Authority—A way of knowing proposed by C. S. Peirce, wherein knowledge is authorized and disseminated by the ruling state, its institutions and experts, and is contested only when the powers that be are successfully ousted.

Method of Intuition—A way of knowing proposed by C. S. Peirce, wherein knowledge is constructed through reasoning based not upon meticulous observations, but upon "truths" assumed to be self-evident by some even while yet invisible to others.

Method of Science—A way of knowing proposed by C. S. Peirce, wherein knowledge is assumed to be most empirically rigorous.

Method of Tenacity—A way of knowing proposed by C. S. Peirce, wherein knowledge is fixed in place simply because the individual or community has habitually and tenaciously believed it to be true.

Natural or Manufactured Material—Any natural substance, product, or physical matter originating from plants, animals, or the earth—or else any synthesized product or fabricated apparatus derived from those natural materials that is a possible focus of inquiry.

Object—From 19th-century philosopher and logician, C. S. Peirce; the initial thing to which the sign or theory in the meaning-making process refers.

Objectivity—The advocacy of disinterest and impartiality as an achievable methodological perspective when in the conduct of inquiry. The biased stance that scientific methods of inquiry are more impartial, unbiased and reliable than any other.

Phenomenon—A fact or situation that is observed to exist or happen or the story of such an existence or happening. A phenomenon is considered to be a possible focus of inquiry.

Philosophical—An *a priori* ABR theory-building practice, proceeding from prior theories and understandings, and derived from a synthetic theoretical perspective.

Physical Theory-building—Attempts to represent the characteristics and relations between physical materials/objects and associated living or human/social phenomena—it primarily requires data about things in natural and fabricated contexts.

Polyphony—Multiple voices working independently yet creating a single texture of contrasts that work together in counterpoint.

Representamen—From 19th-century philosopher and logician, C. S. Peirce; the mediating tool selected as an initial point of reference in an inquiry, one with some likely potential to validly re-construct that object in cognition.

Synthetic (ABR Theoretical Model)—Involves thinking in a language, dialectically navigating shared symbolic and problem-solving systems.

The Scientific Method—Part of a powerful narrative mythology about the preeminent place of logical positivism and the Western mind in the pantheon of knowledge-making.

Tools of Inquiry—The selected mediating instruments of research theory-building.

Arts-Based Research as Analytic Research Practice

Postmodern Precedents for an Analytic Arts-Based Inquiry Architecture

In the spirit of Charles Sanders Peirce's admonition that we do nothing that bars "the gate of inquiry" (cited in Buchler, 1955, p. 57), it is important to view with open eyes some of the precedents that have made possible a subsequent discourse on the characteristics of analytic arts-based theory-building and exemplars of its practice. My aim in this chapter and the remainder of this textbook is not to mark out an alternative research paradigm, but an autonomous paradigm that generates its own language, meaning, and possibilities—rather than one being ever modified to survive the onslaught of criticisms often suffered by qualitative researchers operating "on the linguistic turf of positivist research" (Guba, 1990, p. 296).

In its autonomy, the analytic portico of the larger arts-based research paradigm architecture dis-

rupts and permeates the rational/irrational binary reified in the traditional divide between quantitative and qualitative research practices. Quantitative research methods are still characterized in many quarters as productive of "hard, firm, real, concrete, solid, and strong" findings—a characterization contradistinguished with persistent metaphors defining qualitative research approaches as "soft, mushy, fuzzy, and weak" (Guba, 1990, p. 295). In place of this hierarchical and polarizing binary, a both/and hybridity has asserted itself anew in the postmodern era: an analytic arts-based theory-building methodology *both* claims "a special status for a particular way of investigation," *and* adapts "both design and method of investigation to the nature of the phenomena at hand" (Guba, 1990, p. 272).

Both/And (vs. Either/Or)

A both/and logic offers a flexible and hybrid strategy for blending inquiry from more than two worldviews and disrupts the limitations of an either/or conceptual binary.

This hybridity of research process and product has become possible because of the postmodern turn in social research that first confronted the mendacity of "the value-neutral claim at the heart of positivist [scientific] authority," revealing it as a position that was "untenable" (Lather, in Guba, 1990, p. 317). The pursuit of science has historically been carried out as a "value-constituted and constituting enterprise," positing "(n)eutrality, objectivity, observable facts, transparent description, [and a] clean separation of the interpreter and the interpreted" as the only valid means toward constructing a hegemony of knowledge (Lather, in Guba, 1990, p. 316). There is nothing unusual in this except the pretense of being value-free. Scientific researchers—like all researchers—naturally "construct their object of inquiry out of the materials their culture provides, and values play a central role in this linguistically, ideologically, and historically embedded project that we call science" (Lather, in Guba, 1990, p. 317).

The postmodern turn in social research has also revealed sociocultural archaeologies supporting the "politics inherent" in historical acts of scientific interpretation—bringing into the open not only the ways in which methodology and epistemology are intimately linked, but the multitudinous ways in

which "methodology is historically situated and... evolves" (Schwandt, in Guba, 1990, p. 261). Given this evolution and the refiguration of the salient terms of research, it is not surprising that a different logic is found to be at play in the analytic exemplars of arts-based research highlighted in this chapter, one that transposes both the "logic of verification" privileged in quantitative and positivist scientific research, and the "logic of discovery" privileged in qualitative grounded theory research (Guba, 1990, p. 296). An analytic arts-based theory architecture is instead an exercise in the logic of deconstruction:

Logic of Deconstruction
A both/and kind of logic that probes the unsaid in our saying in order to expose its hidden internal assumptions and contradictions and subvert its apparent significance or unity.

As an analytical place, deconstruction moves from the either/or logic of ranked binaries to a both/and logic that probes the unsaid in our saying. (Lather, in Guba, 1990, p. 328)

In the following example of arts-based research, Dr. Teresa Morales presents a theory-building process that began with the investigation of a *physical* problem and a primary research question that sought to interpret and represent material/object properties and phenomena—in this case, the Régence Room, an eighteenth-century French period room at the J. Paul Getty Museum in Brentwood, California.

Figure 16. The Régence Room (71.DH.118), ca. 1997, J. Paul Getty Museum, Brentwood, California (Photo courtesy of the J. Paul Getty Museum)

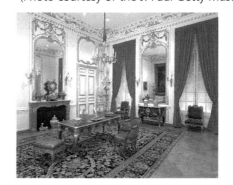

Currently an arts consultant, Morales asked: *How did the methodology of the exhibition development process of the Régence Room affect its interpretation?*

Period rooms are practical locations for exploring themes of lived experience in all its variety across social strata. But visitors rarely conceive of this because the Régence Room is presented, like the majority of museum period rooms in other institutions, according to a single traditional perspective developed nearly one hundred years ago. This conventional perspective is basically putting furnishings in a room to give an illusion of a historical context, blocking visitors from entering the room completely by using stanchions and ropes or fences, and positioning object labels with cursory text. (Morales, 2011a, p. 4)

Morales thus set out to investigate the traditional exhibition design and interpretation of the Régence Room and its furnishings, along with their potential efficacy in conveying even more complex messages, communicating multiple narratives "as a forum to study social history through objects of material culture . . . or as a place for visitors and educators to learn about the world and their place in it" (Morales, 2011a, p. 4). In order to address her primary question, Morales deployed an analytic method aptly involving a detailed examination of the material elements and structure of the Régence Room—*thinking in historical materials and artifacts.* However, her list of secondary and subset questions reveals an intent to produce a deconstructive yet *logically derived* outcome based upon that detailed examination—yielding a syntactical exploration of the media and techniques for manipulating material culture objects, an accepted means for curating selected bits of social information within museum settings. Morales asked:

And what about the persons who owned the objects? How did they use the objects? How would the objects have been positioned in a particular room? What did the objects symbolize in their his-

torical context, and what do they continue to symbolize in terms of, for example, social status and political economy?...Why and how did the museum acquire them? Why and how were they restored? Why and how were they displayed the way they are?...What can the elaborate decorative objects represented in the room tell us about the people that used them? What can they tell us about the people who are absent from these scenes? For instance, servants? How did they live? What were their relationships to aristocrats? What objects did they own and use, and what did they look like? Who was the audience for contemporaneous drawings and prints that represented aristocratic life? What can be learned by the Museum's choice in collecting only luxurious, aristocratic objects? (Morales, 2011a, p. 6)

Autoethnography

A social research method that blurs the boundaries between individual reflexivity (auto-), the transcription of collective human experience (-ethno-), and writing as a form of inquiry (-graphy).

Utilizing an observational and interview approach incorporating thick, rich descriptions, autoethnography, and ethnographic drama, Morales *both* paid homage to "the setting of the Régence Room and the situation of its display," *and* in contrast worked to resist "authoritative conventions with aims at accuracy, truth, and objectivist notions of cultural reality" (Morales, 2011b, p. 1).

Morales' analytic theory about museum period rooms (See Figure 17) is intended to represent the

Figure 17. Theorizing museum period rooms

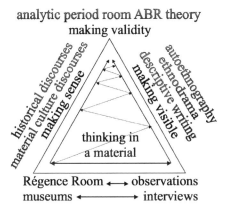

"intangible dynamism of a period room" in that "the room and its furnishings are open to numerous interpretations and therefore serve as various doorways to learning and meaning-making" for the gallery visitor (Morales, 2011a, p. 5). The internal validity of this theory is ultimately evidenced by an arts-based ethnographic drama titled *Requiem for a Room*, written by Morales as part of the process of simultaneously *making visible* and *making sense*.

Viewed through the ABR theory-building algorithm T = E ÷ I, Morales' lived, acquired, and negotiated experience with museum gallery spaces, material culture objects and their histories first hones in on a data set including the J. Paul Getty Museum's Régence Room and its social contexts—discovering the initial covalence of that data set with selected methodologies for making inherent meaning more visible. Morales' *logical* theory-building approach was undertaken in the address of a research question about a *physical* space, first engaged through deeper observation and interviews, and then further mediated by descriptive, autoethnographic, and ethnodramatic interpretants. As of this writing, Morales is currently "collaborating on an exhibition at The J. Paul Getty Museum based on her doctoral research related to the exhibition development and interpretive process" of the Régence Room (Morales, 2011a, p. 2).

Laura Reeder, a doctoral student at Syracuse University, presents a theory-building process that begins with the investigation of a *hominological* problem and a primary research question seeking to interpret and represent human/social properties and phenomena—using in this case the metaphor of the *exquisite corpse* as an analytic structure for better understanding the identity of the teaching artist, an identity Reeder shares. The *exquisite corpse* was a parlour game invented by surrealist artists in the early 1900s, a method for collectively assembling words and images for the sake of the emergent meanings that invariably arose from their juxtapositions (See Figure 18). Through this lens, Reeder has

Ethnodrama

Ethnographic drama, a live performance of research subject experiences, or a researcher's analysis and interpretation of collected data for an audience.

Figure 18. Exquisite corpse schematic

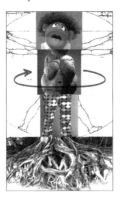

begun an exploration in search of "a more holistic description" of the teaching artist, an identity that collides with and/or attaches itself to that of the artist-teacher, the "certified" teacher, the artist-researcher, and the cultural worker or institutional attaché (Reeder, 2011, p. 3).

The metaphor of the exquisite corpse lends itself as a material object for empirically understanding the variations of the teaching artist identity as a "hyphenated" identity construct in the postmodern era (Cohen-Cruz, 2010, p. 170). Reeder's research poses the question: *What are the qualities of teaching artist professional identities that might be relevant to overlapping social, educational, and artistic paradigm changes?*

> When I am in a school, between the hours of 8:00 to 3:00, I am conscious of my membership in a world of "certified" teachers. In this role, with my earned credentials in hand, and history as an art teacher in public schools, I contribute to construction of a "collective self" . . . with teachers and their definitions of "other" non-teachers in society: administrators, students, parents, and more who may influence their work. With the subtle shift of a metaphorical fencepost, I can become a teaching-artist because I am not on the district payroll anymore, I have the freedom to come and go during the day, and I am affiliated with a cultural organization. I now have "other" membership, and there

is a tangible distance between teaching-artist and art teacher defined by perceived or practiced agency and intention. On the teaching-artist side of this fence, I am either/or, either special guest or interrupting visitor. (Reeder, 2011, p. 3)

Reeder thus sets out to explore the useful ambiguities in the assemblage of teacher identity within institutional contexts, a crucial "analysis of identity and interaction within and surrounding an artist educator" in an era that demands the preparation of teachers qualified to serve as facilitators in the development of 21st-century creative classrooms capable of equipping learners to innovate, compete and excel in the global, networked knowledge economy (Reeder, 2011, p. 5).

In order to address her primary question, Reeder proposes an analytic arts-based theory architecture that empirically deconstructs innate and lingering presumptions about teachers and "non-teachers" in school and out of school—*thinking in collaged discursive materials* about those social agents most influential over schooling expectations and learning outcomes. *What are some of the multiplicity of ways in which to construct a teaching identity? How might marginalized arts teaching identities inform the construction and deconstruction of "non-arts" teaching identities?* (See Figure 19).

Figure 19. Theorizing teaching artist identity

analytic teaching artist identity ABR theory
making validity

arts-based discourses
qualitative discourses
making sense

content analysis
semi-structured interviews
making visible

thinking in
a material

teaching artists ←→ exquisite corpse
narratives ←————→ collages

To further build upon these questions, Reeder pursues the empirical capture of qualities of identity as collaged outcomes—rigorously formulaic representations—an exquisite corpus of symbols *both* referencing *and* wrestling perceptions of teacher identity and associated milieus. Reeder documents the initial data-gathering process as follows:

> Over a six-month preparatory period, I engaged in exquisite corpse dialogues with students, artists, teachers, community activists, and researchers. These dialogues were conducted as follows: (1) as rehearsal of the original parlour game with elementary students drawing on folded paper, (2) as expansion of the parlour game with art education Methods students creating folded and co-constructed collages about artist-learner-teacher imagery, (3) as written narrative description with an education research colleague, (4) as an auto-ethnographic examination of my own artist, learner, teacher, researcher origins and motives... (5) as a series of book chapters among a community of multiple-disciplined artists and community activists, and (6) as a mixed media collage with non-arts classroom teachers from a large urban school district during a summer professional development retreat. (Reeder, 2011, p. 4)

Strategically utilizing the situational analysis of semi-structured improvisatory interview-exchanges as guided by observant participation methods and a content analysis of narratives from teaching artists, Reeder *both* problematizes the traditional conception of the "certified" art teacher in public schools, *and* aligns it with the emerging identity of the artist as cultural worker in the 21st century (Reeder, 2011, p. 3). Reeder's analytic theory-building about teaching artist identity is intended to represent the "the contested qualities of either/or artist/teacher" for the professional educator (Reeder, 2011, p. 5).

Viewed through the ABR theory-building algorithm $T = E \div I$, Reeder's lived, acquired, and negoti-

ated experience as an arts teacher and teaching artist in public schools and museum/gallery spaces first hones in on a data set including the intersecting and multiple identities of teaching artists, their K-12 students, and college students learning to be teachers in contemporary society—discovering the initial covalence between these identities and selected methodologies for making their meaningfulness visible. Reeder's empirical theory-building approach is undertaken in the address of a research question about the *hominological* imperative to cultivate new creativity, with data first engaged through dialogue and a parlour game, and then further mediated through visual-textual case studies and other descriptive, ethnographic interpretants.

How to Write an Analytic Arts-Based Research Paper

Writing a research paper utilizing an analytic arts-based method involves thinking and learning logically through observation, experience, and/or experimentation. In my 2004 research article "Messing with Identity Constructs: Pursuing a Post-structuralist and Poetic Aesthetic," I addressed the significant hominological problem of managing of a spoiled identity in the wake of an identity crisis (Goffman, 1963; Rolling, 2004). The question at the center of my inquiry was: How does an individual or social group engage a process that un-names and re-builds a wounded self-image—recoding and reconstituting their own subjectivity—negotiating both "the trauma of identity formation and the demands of public life?" (Giroux, 1995, p. 5)

Following from Kenneth Gergen's (1991) observations viewing identity crises as endemic to the current human condition, I was initially compelled to write this essay as a means for examining my own identity crisis after the unexpected death of my father in the summer of 2002. Just as unexpected to me was its acceptance for publication in a major

peer-reviewed research journal and its incorpora-
tion as a chapter in my doctoral dissertation.

In this research paper, I utilized an analytic arts-
based research approach to model for the reader—in
a logical progression—modernist, postmodernist,
and poststructural methodologies available to us in
the contemporary era for assembling and reconsti-
tuting our identity constructs and their encompass-
ing subjectivities.

My writing built up a theory about the shape-
shifting character of human social identity, com-
prised of stories that are structures in flux,
ill-structured potentialities. The poetic nature of my
writing was intended as an exemplar of how the arts
practices provide much more than just illustrations
of already formulated ideas, also becoming a mode
of thinking in and of itself, a preface to acts of trans-
ference—personal meanings rendered meaningful
to the reader.

In this writing I present myself as a child again, re-
constituting blue worlds, regaining alternative
homes, extra-normal realities, positioned outside
of adult constraints and considerations. Outside
the home of my father. Outside of schooling. Out-
side of my anxious body. I am removed to recesses;
I am un-named in this writing. I am an unknown
body. I am repositioned outside of my postgradu-
ate education and its limitations, outside of my
racial 'homeland' and its restrictions, free to play
against the fences that compartmentalize identi-
ties, wandering along the margins where stories
change and I become whoever I want to be. When
I was a child, I spake as a child, I thought as a
child, I deconstructed the texts that constituted
me as my father's child, making myself at 'home'
whether in a bus or in the schoolyard, whether in
a crowd or totally alone. In retelling the texts of
those early deconstructions, I free my body from
the modernist project, freeing myself from an es-
sentialized story—freeing it from certainty, fixity
and the injuries boundedness ultimately brings.

In the end I breathe easier, free of my asthma.
(Rolling, 2004, p. 555)

The research article concludes as a representa-
tion of my life experience interpreted through vary-
ing scripts. Modernity says that "to see is to know,"
that I have been to the X on the universal map and I
can prove it. Postmodernity says that "to know is to
see," that I have read through the multiple texts
that map my body and its position; hence, I am con-
stituted by each given text while at the same time,
in turn, rewriting that text—turning the page. A
poststructuralist repositioning of identity argues,
"to move is to see." Space, time, and experience
form a continuum far too situationally in flux to
map, yet infinitely researchable.

Analytic Arts-Based Curriculum-making Strategies for Educational Practice

Analytic Arts-Based Curriculum-making Strategy

A curriculum-making strategy for the arts and design in education that involves thinking in a material or formal technique, wherein materials, phenomena or physical objects become the site of research or student learning.

Analytic art-making practices are material-specific
strategies for learning—constituting arts-based bod-
ies of knowledge out "of" materials and the known
canon of techniques for rendering them meaningful.
Analytic arts-based curriculum-making recognizes
Thinking in a Material or Formal Technique as a viable
exercise in learning behavior. The shaping and appli-
cation of artistic mediums becomes a methodology
for meaning-making—and materials, phenomena or
physical objects become the site of research or stu-
dent learning. Analytic art-making practices yield at
the very least the following strategies for classroom
learning, with more to be named by others.

Empirical Investigation

An analytic research and teaching/learning strategy generating new meaning through formulaic analysis of materials, objects, phenomena, relationships and/or events in the world.

Empirical investigation is an analytic research
and teaching/learning strategy generating new
meaning through formulaic analyses of materials,
objects, phenomena, relationships and/or events in
the world. The artist and architect Maya Lin employs
this strategy in conceiving her works, analyzing
sculpture and architecture from culturally diverse
sources, including Japanese gardens, Hopewell In-

dian earthen mounds, and works by American earthworks artists of the 1960s and 1970s. Her wellspring of experience with these sources for her practice is evident in perhaps her most famous interpretation, the Vietnam Veterans Memorial.

Tim Hawkinson is another artist who employs empirical investigation in his art-making practices. In the following excerpt from the website of the Peabody Award-winning Art21 PBS television series—which features and highlights the thinking of artists producing work in the 21st century—we are offered insights into Hawkinson's exploration of forms and procedural formulas as a means for making sense of identity and the world:

> Hawkinson is renowned for creating complex sculptural systems through surprisingly simple means. His installation, "Überorgan"—a stadium-size, fully automated bagpipe—was pieced together from bits of electrical hardware and several miles of inflated plastic sheeting. Hawkinson's fascination with music and notation can also be seen in "Pentecost," a work in which the artist tuned cardboard tubes and assembled them in the shape of a giant tree. On this tree, the artist placed twelve life-size robotic replicas of himself, and programmed them to beat out religious hymns at humorously irregular intervals. The source of inspiration for many of Hawkinson's pieces has been the re-imagining of his own body, and what it means to make a self-portrait of this new or fictionalized body. In 1997, the artist created an exacting, two-inch-tall skeleton of a bird from his own fingernail parings, and later made a feather and egg from his own hair; believable even at a close distance, these works reveal Hawkinson's attention to detail as well as his obsession with life, death, and the passage of time. (Retrieved February 11, 2012 from http://www.pbs.org/art21/artists/tim-hawkinson)

Replication
An analytic research and teaching/learning strategy generating new meaning in the form of reenactments of prior meaning through revisited materials, objects, phenomena, relationships, and/or events in the world.

Replication is an analytic research and teaching/learning strategy generating new meaning in the form of reenactments of prior meaning through

revisited materials, objects, phenomena, relationships and/or events in the world. Pepón Osorio employs this strategy in his large-scale installations replicating his experience growing up as a child of Puerto Rican parentage and as a social worker in the Bronx, New York interacting with the neighborhoods and people among which he was working.

Sally Mann also employs replication in her photographic art-making practices. The following excerpt from the Art21 PBS website explains Mann's replication not only of historical photographic processes, but also her replication of family intimacy in her systematic analysis of her closest personal relationships:

> Her early series of photographs of her three children and husband resulted in a series called "Immediate Family." In her recent series of landscapes of Alabama, Mississippi, Virginia, and Georgia, Mann has stated that she "wanted to go right into the heart of the deep, dark South." Shot with damaged lenses and a camera that requires the artist to use her hand as a shutter, these photographs are marked by the scratches, light leaks, and shifts in focus that were part of the photographic process as it developed during the nineteenth century. (Retrieved February 11, 2012 from http://www.pbs.org/art21/artists/sally-mann)

Decryption
An analytic research and teaching/learning strategy reconstituting and transforming potential meaning through decoded and recoded materials, objects, phenomena, relationships and/or events in the world.

Decryption is an analytic research and teaching/learning strategy reconstituting and transforming potential meaning through decoded and recoded materials, objects, phenomena, relationships and/or events in the world. Julie Mehretu's paintings and drawings make sense of the turbulence of metropolitan geographies and architecture, decoding the chaotic fragments that define contemporary living and re-patterning these elements into a densely overlaid spatial cartography constituted of flying and coalescing urban grids and structures.

Fred Wilson employs decryption in his art-making practices. On the Art21 PBS website we see an ex-

planation of Wilson's unorthodox approach to art-making as a curator of artifacts. Wilson constructs intelligible meaning out of disparate and apparently unrelated elements located in museum collections, artifacts that are decoded, juxtaposed, re-presented and thereby recoded for an unexpecting audience:

> . . . Wilson creates new exhibition contexts for the display of art and artifacts found in museum collec-tions—including wall labels, sound, lighting, and non-traditional pairings of objects. His installations lead viewers to recognize that changes in context create changes in meaning. While appropriating curatorial methods and strategies, Wilson main-tains his subjective view of the museum environ-ment and the works he presents. He questions (and forces the viewer to question) how curators shape interpretations of historical truth, artistic value, and the language of display—and what kinds of bi-ases our cultural institutions express. (Retrieved February 11, 2012 from http://www.pbs.org/art21/artists/fred-wilson)

An example of an analytic teaching/learning strategy successfully elicited through the art educa-tion curriculum is a special project I engineered for one of my second grade classes involving the con-struction of an accurate scale model of their class-rooms. During a unit on the building and structure of our brand new school building, I worked with one classroom of second graders to measure out and construct an accurate scale model of the floor in our building that was home for the second grade. The final work was going to be prominently displayed and so the students were acquainted with some of the challenges of model construction.

Because I had studied architecture prior to my degrees in the visual arts and had practiced as a free-lance architectural model maker for a couple of years, I was able to facilitate the construction of any-thing a student wished to build utilizing replication as an art-making and learning methodology. We

primarily used wood, cardboard and foamcore—common materials in the model making profession. Our learning objective was to make a detailed analysis of architectural maps, understand proportional relationships between schematic elements and their constructed realities, and construct replications of actual color schemes, furniture, and furnishings. Analytical approaches to arts and design education pedagogy offer up a rich array of possibilities for learning.

Glossary

Analytic Arts-Based Curriculum-making Strategy—A curriculum-making strategy for the arts and design in education that involves *thinking in a material or formal technique*, wherein materials, phenomena or physical objects become the site of research or student learning.

Autoethnography—A social research method that blurs the boundaries between individual reflexivity (auto-), the transcription of collective human experience (-ethno-), and writing as a form of inquiry (-graphy).

Both/And (vs. Either/Or)—A *both/and* logic offers a flexible and hybrid strategy for blending inquiry from more than two worldviews and disrupts the limitations of an *either/or* conceptual binary.

Decryption—An analytic research and teaching/learning strategy reconstituting and transforming potential meaning through decoded and recoded materials, objects, phenomena, relationships and/or events in the world.

Empirical Investigation—An analytic research and teaching/learning strategy generating new meaning through formulaic analysis of materials, objects, phenomena, relationships and/or events in the world.

Ethnodrama—Ethnographic drama, a live performance of research subject experiences, or a researcher's analysis and interpretation of collected data for an audience.

Logic of Deconstruction—A both/and kind of logic that probes the unsaid in our saying in order to expose its hidden internal assumptions *and contradictions and subvert its apparent significance or unity.*

Replication—An analytic research and teaching/learning strategy generating new meaning in the form of reenactments of prior meaning through revisited materials, objects, phenomena, relationships, and/or events in the world.

Arts-Based Research as Synthetic Research Practice

Postmodern Precedents for a Synthetic Arts-Based Inquiry Architecture

Synthetic Arts-Based Curriculum-making Strategy

A curriculum-making strategy for the arts and design in education that involves thinking in a language, wherein the reinterpretation of discourse and narratives within communities of practice becomes the site of research or student learning.

The start of the postmodern era has also worked to move the ongoing debate about research methods "beyond considerations of a single research methodology or paradigm" toward the possibility of undertaking inquiry as a "multiple-paradigm endeavor" (Skrtic, 1990, p. 135). Scholars in educational and social research have entered a phase of "dialogical discourse—an antifoundational, reflective discourse about, and appreciation of, the variety of available research logics and paradigmatic perspectives" (Skrtic, 1990, p. 135). This has enabled a synthetic inquiry architecture that is premised upon "the reconceptualization of the nature of knowledge itself" (Skrtic, 1990, p. 134).

At the heart of this reconceptualization is the postmodern observer, able to surround the data by shifting from knowledge foundation to knowledge

foundation—resituating his or her perspective as a knower from one research paradigm to another. One cannot understate the breakthrough involved in reconceptualizing inquiry "as a form of interaction between an object of study and an observer" rather than from the traditional static scientific stance "that there is a fixed set of foundational criteria against which all knowledge claims can be judged" (Skrtic, 1990, p. 134). Research may now be viewed as a dynamic human engagement requiring a dialogical dance of inquiry that synthesizes multiple perspectives into an emergent, often transitory, theoretical point of view.

> Thus, the point is not to accommodate or reconcile the multiple paradigms of [contemporary research]; it is to recognize them as unique, historically situated forms of insight; to understand them and their implications; to learn to speak to them and through them; and to recognize them for what they are—ways of seeing that simultaneously reveal and conceal. (Skrtic, 1990, p. 135)

With each bias a researcher brings to a research inquiry revealing as much as it conceals, the heterogeneous and amalgamated perspectives necessitated in the construction of a synthetic theory architecture ensures "a democratized discourse"—offering broad access to cross-disciplinary tools and methods of inquiry, while yielding a widespread relevance of research outcomes to "intersubjective communities of inquirers" (Skrtic, 1990, p. 135).

In the following example of arts-based research, Dr. Kristopher J. Holland presents a theory-building process beginning with the hybrid investigation of *both* a *physical* problem *and* a *hominological* problem, along with a primary research question that seeks *both* to interpret and represent material/object properties and phenomena *as well as* human/social properties and phenomena. In this case, Holland explores the creation and use of a work of contemporary art as a synthesizing vehicle for imagining

Intersubjective
Democratized discourse within communities of behavior and/or practice that exists, occurs, or holds consciousness between minds.

and then realizing a grand theory first proposed by German sociologist and philosopher Jürgen Habermas (1985) as a means of knowing the nuances of human interaction.

The Habermas Machine has been under construction since 2006 as a conceptual art installation that works to interrogate "the practice and use of philosophical inquiry via writing" by functioning as a contestation of "Western 'normative' philosophical inquiry methodologies" biased toward envisioning "reading and writing as the gateway to understanding complex ideas" (Holland, 2011, p. 8). Holland asks: *Can conceptual art be used as philosophical inquiry?* Holland's machine is a heterogeneous amalgamation of eleven complexes, each complex dealing with an aspect of Habermas' theoretical writings on "how knowledge is structured communicatively" through inter-subjective experience—social interaction which is argued to be "foundational to meaning making activities that form the core of human life" (Holland, 2011, p. 2). *The Habermas Machine* installation is intended to be an interactive space for multiple users wherein "the physicality of the piece and the intentionality of the users" are manifested as communicative acts (e.g., speaking, drawing, marking, performing, etc.) serving to "expand the way we think *and* use ideas in non-discursive forms" (i.e., rather than writing), helping to grasp metaphysical concepts in an experiential way (Holland, 2011, p. 4).

The *physical* acts of the actual interactions and experiences with the conceptual art pieces (the wood, plastic, glass, paper, 'making special' activities, etc.) are intended to foreground the 'physical space' of philosophical inquiry. Typically reading and writing are the physical dimensions that impact learning and knowledge transmission as in one reads a book, and writes an argument. But what of the contemplative space that is not a book or computer screen? What of the reflective space generated in communicative art experiences? To change the physical space of 'doing philosophical inquiry' into

a conceptual art realm is one of the major aspects this work seeks to explore. (Holland, 2011, p. 4)

Holland—an Assistant Professor of Art Education at the University of Cincinnati—thus sets out to explore Habermas' theory of communicative rationality through a physically constructed inter-subjective architecture intended to inaugurate a work of conceptual art as a "generative site" for philosophical inquiry operating beyond the limits and boundaries of formal written language (Holland, 2011, p. 4).

In order to address his primary questions, Holland has constituted a synthetic method, coalescing his systematic assembly of the material elements and structure of *The Habermas Machine* to work in concert with a "highly complex philosophical system" (Holland, 2011, p. 3)—*thinking in constructed materials and ultimately in a common language inter-subjectively wrought by the machine participants.* The resulting synthesis takes dense and difficult-to-translate Habermasian themes which typically require "years of reading and reflection to unlock" and instead activates them within the realm of the philosophical imagination—rendering them accessible enough to be readily "experienced, reflected upon, and *practiced*" within what is ostensibly a functional piece of synthetic arts-based theory architecture (Holland, 2011, p. 3).

Holland's machine is constructed to yield *philosophical* outcomes that are alternatively *descriptive*, *explanatory*, and *interpretive* based upon the "social interaction of the subjects involved in learning" (Holland, 2011, p. 4). It is useful to note Holland's

Figure 20. *The Habermas Machine:* Under construction/ in progress, Kristopher Holland [2006-2012]

description of Complex 3 of *The Habermas Machine*, focused on the concept of pure-subjectivity and on affording privileged access to what is typically part of the subjective experience. In order to relay such experience adequately to another person, it must be mediated through presupposed linguistic common- alities. The "communicative rationality and action" at the core of Habermas' inter-subjective framework is hypothesized to be found in evidence as one sub- ject voices personal experience to another, giving that experience new life in the next subject's imagi- nation (Holland, 2011, p. 6). Complex 3 illuminates the concept of pure subjectivity in this way:

> To experientially parallel this concept, two partici- pants are tasked to verbally communicate what a provided 'visual work' or image looks like, but only one participant is given the image; the other is blind to it. Thus, the student is trying to describe an art piece to another who is attempting to make sense of the object without seeing it, only being told what it 'looks like.' The challenge starts with easily recognizable images and incrementally grows in difficulty to abstract ones. The build from 'real- ism' to abstraction (which could be done either way) is evoked, but the point is that there would be almost no way for the person who sees the object to be able to have the other person 'see' what they see. The privileged position of the first participant is fore-grounded by the frustrating experience the second student has trying to figure out the details and recreating the object. As the object is finally re-

Figure 21. *The Habermas Machine:* Complex 3, Kristopher Holland [2006]

Figure 22. Theorizing human interaction

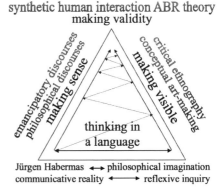

synthetic human interaction ABR theory
making validity

emancipatory discourses
philosophical discourses
making sense

critical ethnography
conceptual art-making
making visible

thinking in
a language

Jürgen Habermas ⟷ philosophical imagination
communicative reality ⟷ reflexive inquiry

vealed to the student, the difference between the reality described to them and the reality they 'see' activates a memory of the conversation and the shortcoming of verbal communication in the descriptive process. (Holland, 2011, p. 7)

Thus, this section of Holland's theory-building assembly navigates, communicates, and reinterprets extant symbolic associations, syntax, social quandaries, or dialogical needs within a "prior communication community" while also bringing to the forefront "the limits of inter-subjective communication" (Holland, 2011, p. 6).

Utilizing an inquiry approach situated within the context of the enacted philosophical imagination, and incorporating conceptual art-making and critical ethnography (See Figure 22), Holland's machine synthesizes three different arts-based research matrices: a *synthetic* architecture to simulate and communicate subjectivity, a *critical-activist* architecture contesting "Western 'normative' philosophical inquiry methodologies," and an *improvisatory* architecture that foregrounds the emergent discourse energized by the experience of conceptual art, discourse as "unpredictable as human interactions themselves" (Holland, 2011, p. 8).

Viewed through the ABR theory-building algorithm $T = E \div I$, Holland's lived, acquired, and negotiated experience with Jürgen Habermas' theories

for how "our everyday lives are founded by inter-subjective experience" first hones in on the data set of Habermas' philosophical descriptions of communicative reality and its "normative, objective, and subjective contexts," discovering the initial covalence of this data with selected methodologies for making its potential meaning more easily visible (Holland, 2011, p. 2). Holland's *descriptive, explanatory,* and *interpretive philosophical* approaches for building theory are undertaken in the address of a hybrid research question about the utility of a *physically constructed* space for understanding an interactive *hominological* phenomenon. Research is first engaged through the philosophical imagination and the mapping of a complex strategy for reflective inquiry, and then further mediated by conceptual art and critical ethnographic interpretants. As of this writing, Holland has acquired funding to complete the project and a formal installation of the machine with all completed eleven complexes was tentatively planned for the winter of 2011/2012.

Rebecca Ann S. Kirk, received her Master of Education in Art, Community and Education from Lesley University and has long been immersed in several arts practices, having studied ballet for 15 years, both modern dance and classical voice as a soprano for four years, and having performed in choirs for the last ten years. Kirk presents a theory-building process that begins with the investigation of a *hominological* problem and a primary research question that seeks to interpret and represent human/social properties and phenomena—in this case, using the choreographic process as a synthesizing structure for comprehending the nature of artistic insecurity. In her effort to teach others to be creative as a community artist-educator, Kirk has repeatedly encountered a deeply embodied resistance, richly described in this passage:

> Throughout my work in arts education I have noticed insecurity—bordering on fear—shared by teachers,

students, parents, and arts patrons, young and old, when participating in an art form with which they are unfamiliar or lack experience. People with such feelings may be reluctant to even make an effort at participation. Even when they try, it may come with expectations of failure and discomfort. Countless times I have received praise and admiration when describing myself as an artist, followed by: "I could never do what you do! I'm tone deaf." "I have two left feet." "I can't draw a straight line." (Kirk, 2011, p. 3)

Embodied fear and insecurity is manifested in the realm of the human emotions, interrupting and confounding creative intellectual processes. Hence, in order to both improve the teaching of creativity and better facilitate creative learning, Kirk has begun an exploration of "the emotional and physical responses many artists experience regarding artistic identity," aligning it with an exploration of the fear and insecurity that stymies the formation of an artistic identity (Kirk, 2011, p. 3).

Aided by her immersion in arts practices, Kirk notes a key discovery in her effort to understand the cultivation of an artistic identity, namely that professional artists "doubt their abilities, talent, and skill dealing with just as much insecurity as novices do in seeking to define themselves as artists and their work as art" (Kirk, 2011, p. 4). However, Kirk's interest was not primarily in how we teach students to be professional artists, but rather to ask: "How do we teach people to be creative?"

Perhaps a chief distinction between these two groups is that professionals . . . are simply more accustomed to managing their insecurity as part of the artistic process [than novices are]. How is this insight helpful? Some choose to pursue the arts and others do not, however everyone has the ability to cultivate creativity. (Kirk, 2011, p. 4)

Kirk thus set out to illuminate the nature of insecurity and its persistent duet with the construction of

creative confidence within the construct of the artistic identities of teachers and students alike. As in the description of Reeder's study in the preceding chapter on analytic arts-based theory-building, Kirk's exploration recognized that we are living in an era that more than ever demands the development of 21st-century classrooms that are equipping learners with the skills to excel in a "creative economy," such as imagination, critical thinking, problem solving, communication, collaboration, flexibility, adaptability, initiative, self-direction, accountability, and leadership (Partnership for 21st Century Skills, 2008).

In order to address her primary question, Kirk proposed a synthetic arts-based theory architecture, thereby *instrumentalizing* her collected data about human subjects as they grappled with fear and insecurity in relation to acts of creation. Kirk accomplishes this by converting that data into the forms and movements of a performed dance, her own artistic medium—*thinking in the choreographed language of embodied emotions*. Through her collaborative dance performance—titled *Not/Alone?* and presented in 2010 at Lesley University—Kirk explored questions such as: *"What does insecurity feel like?" "What do you do or not do as a result of your insecure thoughts and feelings?" "What is the result of these actions or lack of them?"* (See Figure 23).

To do this I have collected survey data from professional and amateur artists. The data, rich with illustrative personal moments, has not only given insight into my understanding of insecurity, it has

Figure 23. Dancing the data

Figure 24. Theorizing creative insecurity

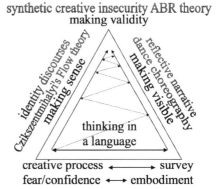

also been a primary source for a deeper, embodied exploration of those intimate emotions through the craft of choreography. Working with a choreographic mentor and two dancers, I danced the data and crafted a ten minute duet that was performed for an invited audience. (Kirk, 2011, p. 4)

To further build upon these questions, Kirk sought to suffuse the capture of survey data about fear and insecurity with "a deeper, embodied exploration of those intimate emotions through the craft of choreography"; Kirk narratively reflects on having "danced the data," working in collaboration with a choreographic mentor and two other dancers who performed the interpretive duet as designed (Kirk, 2011, p. 4). So on one hand, Kirk's synthetic inquiry architecture yielded an artistic practitioner's *craft-based* outcome, of utilitarian value in the choreographing of a new dance—and on the other hand, Kirk's theory architecture yielded a curriculum designer's *applied* outcome in her effort to better address the problem of negotiating the variegated relationship between creative confidence and fear.

Kirk also draws upon the theory of positive psychology outlined by Mihaly Csikszentmihalyi (1990), wherein a subject is able to channel all emotions, including insecurity and anxiety, toward the confident achievement of his or her creative goals (See Figure 24). Kirk's synthetic theory-building

about creative insecurity is intended to validate the place of insecurity within the creative process and to affirm "that the creative process is both possible and essential to cultivate not only for artists, but for everyone" (Kirk, 2011, p. 2).

Viewed through the ABR theory-building algorithm T = E ÷ I, Kirk's lived, acquired, and negotiated experience as an arts practitioner researching the impact of art-integrated curriculum first hones in on the data set of personal stories of the creative process and the conflict between confidence and insecurity, discovering the initial covalence of those states of mind with selected methodologies for making their meaningfulness visible. Kirk's synthetic approach for building theory is undertaken in the address of a research question about the *hominological* imperative to cultivate uninhibited creativity, first engaged through survey instruments and "exploratory inquiry of embodied learning" (Kirk, 2011, p. 1), and then further mediated by reflective narrative and choreographed dance interpretants.

How to Write a Synthetic Arts-Based Research Paper

Writing a research paper utilizing a synthetic arts-based method involves thinking and learning philosophically, outwardly describing, explaining, or interpreting information about current knowledge. My 2009 co-authored research article "Two Hours or More Away From Most Things: Re:writing Identities From No Fixed Address," is a collaboration with Dr. Lace Brogden, a curriculum theorist at the University of Regina in the province of Saskatchewan, Canada. In this article we played with collaborative and poetic dialogue, deconstructing textual hierarchies between the "main" text body and footnoted text as a means of interrogating ways identities are written/performed (Rolling & Brogden, 2009). The hominological questions at the center of our inquiry were: How do we construe and re:con-

strue (Bruner, 1995) the (archi)textures of (written) life? What is belonging when identities are temporal and where naming remains elusive or unknown (Cixous & Sellers, 2004)?

Our writing was inspired by casual correspondences between Lace and me as friends and academics initiated in relation to three previous works we had individually published in the research journal *Qualitative Inquiry*—either influencing or referencing one another in writing that originally emerged from the shared loss of our fathers. Yet in this particular case, our poetic dialogue was premised on the amusing discovery that Regina, just like State College, Pennsylvania—home of the main campus of Penn State University where I had been newly hired to serve as an assistant professor—was considered a place pretty much two hours or more away from any other significant region on a local map. We began to reflect on the implications of Lace's rootedness in the isolated climes of what she called the "Prairie," my newfound rootedness at that point in time within an obscurely named locale known as "Happy Valley," and its effect upon our self-awareness as academics whose identities were still clearly in motion. This article would also be my very first co-authored publication; the prospect of synthesizing my theory-building approach with the point of view of a distant colleague was an alluring challenge for me as a lone wolf wordsmith with a decidedly solitary writing practice.

In our research paper, I utilized a synthetic arts-based research approach to model for the reader the power of deliberate and non-hierarchical dialogue toward generating unexpected new methodologies for research. My approach was literally to undermine traditional research writing practice—even though I was the lead author, all of my writing for the article was relegated to the footnotes. By doing so, I invented a methodology that might be referred to as *burrowing*. I first encountered this concept in an unpublished conference paper presentation in Manchester, England by a graduate research stu-

dent. In Sophia Kosmaoglou's (2006) abstract she introduced the concept of the *burrow* as a "non-determinist structure" that "also underlines the self-referential process of creating structure from movement, especially repetitive movement indiscernible from habit" (p. 2). I, in turn, took my own page-by-page repetitive movement, trawling through the footnotes of my writing with Lace, to be indiscernible from our overall "re:writing" intent as we theorized about the writing and rescripting of identities.

Our writing dialogue built up a theory about the fluid margins of identity, a continuous storyline—sometimes right on the surface of the individual, pairing, or social group, and sometimes buried deep in the footnotes. In this case, the unorthodox nature of our research dialogue became an exemplar of arts-based methodology-making wherein several methods may be woven together, unraveled, or abruptly sheared away on the way toward a momentary conclusion; along such peripatetic journeys, there is no guarantee as to what the methodological process may yield, nor any disclaimer against what theoretical boundaries may be breached.

> I, James (of sound mind and single name), come to this autobiograph(icall)y writing from the margins, from the bowels, the nether regions, writing from the buried bones, from the footnotes of where certainty is typically constructed, one of my favorite places for the insinuation of atypical and anomalous forms of identity. It is interesting that I push myself to this quiet place, a place of oft-neglected reading, off the map of traditional social science theorizing. I am comfortable here as I discover I cannot bring myself to interrupt Lace's text and landscape. She is my co-conspirator, my collaborator—she has been *driven* to the writing first. In honor of her bravery, of her breathing of words, I write a more obscure trail that fewer will choose to follow; I choose the lesser-traveled 10-point font. (Rolling & Brogden, 2009, p. 1142)

The completed article engaged in a philosophical dance of inquiry, synthesizing perspectives from art education and curriculum studies into an emergent, and transitory, theoretical point of view about the inability to pin identity down, and of the necessity to read between the lines of identity without fear of what will be discovered there:

April 11-12, 2006

Dear James of one name	*Weaving again with Lace*
multiple fissures	*along unseemly seams*
naming and un-naming	*naming and un-naming*
echoes	*silences*
refrains	*remain*
music in the key of sky	*key changes more than the sum of our fears.*

(Rolling & Brogden, 2009, p. 1151, emphasis added)

Synthetic Arts-Based Curriculum-making Strategies for Educational Practice

Synthetic art-making practices are language-specific strategies for learning—constituting arts-based bodies of knowledge "between" the lines of selected arts practices and life experiences. Synthetic arts-based curriculum-making recognizes *Thinking in a Language* as a viable exercise in learning behavior. The reinterpretation of discourse and narratives becomes a methodology for meaning-making—and communities of practice becomes the site of research or student learning. Synthetic art-making practices yield at least the following strategies for classroom learning, with more to be named by others.

Discourse transference is a synthetic research and teaching/learning strategy generating new meaning through deep immersion into a stream of discourse emerging from interacting artistic practices and/or life narratives as a tributary for new re-search. Nancy Spero, a pioneer in feminist art, has employed dis-

Discourse Transference
A synthetic research and teaching/learning strategy generating new meaning through deep immersion into a stream of discourse emerging from interacting artistic practices and/or life narratives.

course transference. Since the 1960s her work has articulated a point of view that locates new sources of power in stories of women protagonists, working so as to contest the hegemonic abuse of power, Western privilege, and entrenched patriarchy.

Yinka Shonibare, MBE is another artist who employs discourse transference in his art-making practices. In the following excerpt from the Art21 PBS website, we are offered insights into Shonibare's trafficking in the critical correspondences between colonialism and post-colonialism, empire and independence, ability and disability—all within the context of autobiographical experience and identity:

> Known for using batik in costumed dioramas that explore race and colonialism, Yinka Shonibare MBE also employs painting, sculpture, photography, and film in work that disrupts and challenges our notions of cultural identity. Taking on the honorific MBE [Member of the Order of the British Empire] as part of his name in everyday use, Shonibare plays with the ambiguities and contradictions of his attitude toward the Establishment and its legacies of colonialism and class. In multimedia projects that reveal his passion for art history, literature, and philosophy, Shonibare provides a critical tour of Western civilization and its achievements and failures. At the same time, his sensitive use of his own foibles (vanity, for one) and challenges (physical disability) provide an autobiographical perspective through which to navigate the contradictory emotions and paradoxes of his examination of individual and political power. (Retrieved February 11, 2012 from http://www.pbs.org/art21/artists/yinka-shonibare-mbe)

Dialogue

A synthetic research and teaching/learning strategy generating intersections between a plurality of arts practitioners, collaborators, and audience members in acts of speculative meaning-making.

Dialogue is a synthetic research and teaching/learning strategy generating intersections between a plurality of arts practitioners, collaborators, and audience members in acts of speculative meaning-making, yielding in the process a rich confluence of experiences as the gene pool for new discourse.

Krzystof Wodiczko employs this strategy in his creation of large-scale video projections on architectural façades and monuments, thus serving as sites of collective memory and dialogue through the public presentation of acts of confession, trauma, grief, fear, anger, and mourning. Wodiczko often solicits these brave acts while participants are most vulnerable, and their raw emotions are key elements of the art-making process.

Allora and Calzadilla also employ dialogue in their hybrid and mixed media art-making practices. The following excerpt from the Art21 PBS website reveals the intent of the artists to use dialogue in the generation of collaborative spaces of inquiry. Allora & Calzadilla often utilize humor as a part of their creative process, educing the participation of their audience as a necessary part of the dialogue—especially as it pertains to the work's commentary on politics, society, and/or democracy:

> Collaborating since 1995, Allora and Calzadilla approach visual art as a set of experiments that test whether ideas such as authorship, nationality, borders, and democracy adequately describe today's increasingly global and consumerist society. Their hybrid works—often a unique mix of sculpture, photography, performance, sound, and video—explore the physical and conceptual act of mark-making and its survival through traces. By drawing historical, cultural, and political metaphors out of basic materials, Allora and Calzadilla's works explore the complex associations between an object and its meaning. (Retrieved February 11, 2012 from http://www.pbs.org/art21/artists/allora-calzadilla)

Disruption

A synthetic research and teaching/learning strategy, interrupting the headwaters of prevailing thought emerging from current artistic practices and/or life narratives.

Disruption is a synthetic research and teaching/learning strategy, interrupting the headwaters of prevailing thought emerging from current artistic practices and/or life narratives for the sake of redirecting and parsing those prior conversations, extending the prevailing discourse toward new possibilities. Cai Guo-Qiang is an artist who employs

disruption. Exploring the properties of gunpowder as his drawing medium at his signature explosion events, Cai draws upon elements of feng shui, Chinese medicine and philosophy, images of dragons and tigers, current events and common cultural artifacts as both metaphor and material in order to synthesize an unrestrained spontaneity in his approach to life and art within the contexts of the highly controlled artistic tradition and social climate in China.

Kara Walker also employs disruption in her artmaking practice. In the following excerpt from the Art21 PBS website, we are offered insights into Walker's use of simple visual narratives to disrupt persistent and corrosive social narratives, new archetypes of consciousness synthesized from stereotypes about race, gender, and subjugation far too long embedded in literature and our collective memory:

> The artist is best known for exploring the raw intersection of race, gender, and sexuality through her iconic, silhouetted figures. Walker unleashes the traditionally proper Victorian medium of the silhouette directly onto the walls of the gallery, creating a theatrical space in which her unruly cut-paper characters fornicate and inflict violence on one another. In works like "Darkytown Rebellion" (2000), the artist uses overhead projectors to throw colored light onto the ceiling, walls, and floor of the exhibition space; the lights cast a shadow of the viewer's body onto the walls, where it mingles with Walker's black-paper figures and landscapes. With one foot in the historical realism of slavery and the other in the fantastical space of the romance novel, Walker's nightmarish fictions simultaneously seduce and implicate the audience. (Retrieved February 11, 2012 from http://www.pbs.org/art21/artists/kara-walker)

An example of a synthetic teaching/learning strategy successfully elicited through the art education curriculum is a project I taught as an after-school teacher at Hunter College Elementary School in New York City. I started off as an instruc-

tor in the Hunter "Clubhouse" extended-day program, teaching Drawing, Painting, Poetry, 3-D Design, etc. and eventually became its director. I created a class called *"Picture This!"* for the Little Room students (our Kindergarteners through 1st graders). The premise was to offer each child an opportunity to synthesize meaning from their experiential store of memories of salient encounters with the world, converting experience into simple word concepts using a methodology of markers and crayons. This was research by the children in a rudimentary form, but research nonetheless.

For example, in one particular class as we sat around a table, I asked the children the question, "What is big?" I solicited discussion, feedback, points, and counterpoints. One child responded, "A dinosaur skull is big." He then recounted a recent museum visit and did a drawing of himself standing in a large cap next to his Dad, the tallest figure in the drawing (see Figure 25). His concept of what "big" is was tied to his memory of an experiential, visual/ spatial encounter in relation to his own body.

The recognitions of the youngsters in this after-school class were *re-cognitions*, visual reinterpretations of previous cognitive activity, generating new learning from a synthesis of experience and drawing practice as prompted by dialogue through an art-making methodology. Synthetic arts-based research recreates, customizes, abandons, dismantles, and refines memories into a knowledge-awareness that changes its shape with time and circumstance. Such changes of mind can be evolutionary and incremen-

Figure 25. Synthesizing an understanding

tal or, in the cases of the stories that suddenly enthrall and overwhelm our attention, the changes can be revolutionary. Whichever the case, these changes of mind can be found in evidence in the drawings of children when drawing assignments are approached as a method for synthesizing meaning.

Glossary

Dialogue—A synthetic research and teaching/learning strategy generating intersections between a plurality of arts practitioners, collaborators, and audience members in acts of speculative meaning-making.

Discourse Transference—A synthetic research and teaching/learning strategy generating new meaning through deep immersion into a stream of discourse emerging from interacting artistic practices and/or life narratives.

Disruption—A synthetic research and teaching/learning strategy, interrupting the headwaters of prevailing thought emerging from current artistic practices and/or life narratives.

Intersubjective—Democratized discourse within communities of behavior and/or practice that exists, occurs, or holds consciousness between minds.

Synthetic Arts-Based Curriculum-making Strategy—A curriculum-making strategy for the arts and design in education that involves *thinking in a language*, wherein the reinterpretation of discourse and narratives within communities of practice becomes the site of research or student learning.

Arts-Based Research as Critical-Activist Research Practice

Postmodern Precedents for a Critical-Activist Arts-Based Inquiry Architecture

In the postmodern era, approaches to research have become more polyphonic than ever before as the epistemological mantle shifted from the presumptive grand narrative of preeminence inherent in the Western project of universal knowledge, toward the navigation of what anthropologist Clifford Geertz (1983) identified as local formulations of cultural meanings, later disseminated. Uncovered in this shift of the inquiry landscape have been "the voices of the formerly silenced and/or marginalized, the voices of all women, men of color, the economically oppressed, postcolonials, lesbians and gays, all those who fail to fit the aggregation and generality at the heart of positivism's explanatory power" (Lather, in Guba, 1990, p. 318).

Philosopher and literary theorist Mikhail Bakhtin (1963/1984) was prescient in articulating

the formational power of "a plurality of independent and unmerged voices and consciousnesses, a genuine polyphony of fully valid voices" (p. 6). One of the consequences of polyphony in the postmodern era of research is that "inquiry methodologies and our standards for judging the implementation of those methodologies develop together and are continually revised by a process of mutual adjustment" (Schwandt, in Guba, 1990, p. 262). Accommodating the polyphony of ontologies within this revised knowledge project requires a constellation of self-validating bodies of knowledge revolving the Western-centric knowledge project in orbits of critique—a system of critique that disrupts the gravity well of Western-centricity from all points of prior marginalization. This constellation of critique is a liminal space that is "unstable, indeterminate, and prone to complexity and contradiction" (Garoian, 1999, p. 40).

The act of realigning new centers of knowledge gravity as they emerge from the margins of the Western-centric knowledge project is simultaneously a political act (hooks, 1990), one that attends to the "transformative potential of the margin" (Herising, 2005, p. 144). Telling the marginalized story, the invisible story, the heretofore unspoken, suppressed or silenced story is a borderland space in research, rich in its potential (Anzaldúa, 1988). Thus, the significance of the marginalized is in becoming an *ex-centric* "site of resistance," encircling and reparameterizing the central or taxonomically centered storyline (hooks, 1990, p. 145).

These shifts and adjustments have together enabled the founding of a critical-activist inquiry architecture premised upon the useful postmodern quandary that "(t)o be critical is to be political" (Rolling, 2008b, p. 2). Critical-activist inquiry is "research that seeks not to prove or disprove, but rather to create movement, to displace, to pull apart and allow for resettlement; it is research that seeks what is possible and made manifest when our taken-for-taxonomic certainties are intentionally shaken"

Ex-centric

An ex-centric approach to research allows for the displacement of privileging ontological and epistemological assumptions away from a central locus of validity and toward the margins of our perceptions.

Critical-Activist Arts-Based Curriculum-making Strategy

A curriculum-making strategy for the arts and design in education that involves thinking through a context, wherein interrogated and contested ideas become the site of research or student learning.

Figure 26. Gulf of Georgia Cannery (Photo courtesy of Ruth Beer and Kit Grauer)

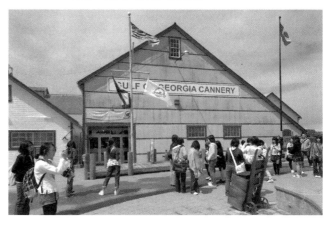

(Rolling, 2011, p. 99). Critical-activist inquiry produces resistance narratives—counter-stories to authoritative grand narratives that are critical, indigenous or local, and anti-oppressive (Brown & Strega, 2005). To be critical is to activate new discourse overwriting prior theory and practice.

Dr. Ruth Beer and Dr. Kit Grauer present a theory-building process that began with the investigation of a *biological* problem and a primary research question that sought to interpret and represent living/ecosystemic properties and phenomena —in this case, the Gulf of Georgia Cannery Museum National Historic Site, the location of an historic fishing village on Canada's pacific coast, once the leading producer of canned salmon in British Columbia.

Beer and Grauer asked: *How can arts-based research and creation of new media artwork create a more complex portrait of the past, and enhance a sense of belonging and regional identity with reference to the fishing industry and cultural and marine environmental sustainability in coastal communities?*

The community-engaged arts-based research new media exhibition *Catch + Release,* was installed at the Gulf of Georgia Cannery Museum National Historic Site in Steveston, British Columbia, a small city on the west coast that once relied on fishing.

That exhibit and upcoming exhibitions adapted for cultural and heritage museum contexts at the First Nations Haida Gwaii Museum at Qay'llnagaay in Haida Gwaii, British Columbia and at Wakayama Museum in the coastal city of Wakayama in Japan propose to advance an encounter with history as critical inquiry into contemporary life of these regions. By applying new media, sensor technologies and tangible interactive tools designed to insert and overlay stories from the community together with those told through the museum, our exhibition is intended to create active viewer participation leading to a more immersive experiences and self-authorship providing unique opportunities for teaching and learning experiences and embodied ways of knowing for museum visitors including a large number of school groups, teachers and community educators. (Beer & Grauer, 2011, p. 3)

Beer is a Vancouver-based artist/researcher interested in interdisciplinary approaches to artistic, collaborative and pedagogical practices as well as Associate Professor of Visual Art and Assistant Dean of Resources and Collaborations; Grauer is an Associate Professor of Art Education and Curriculum Studies at The University of British Columbia. In collaboration, these two researchers set out to explore this still intact cannery as "an important space for critical thinking and a major source of regional identity" (Beer & Grauer, 2011, p. 2).

In order to address their primary questions, Beer and Grauer conceived a critical-activist and interactive arts-based method that incorporated "immersive technology, including interactive projections of visualized data from ocean sensors, and video interviews with professionals related to the fishing industry" (Beer & Grauer, 2011, p. 2)—*thinking through layered contexts of historical regional identity and contemporary local relationships to global ecology. Catch + Release* is comprised of several works through which Beer and Grauer asked:

How do we understand or otherwise contextualize pedagogical collaborations between artists, educators, and museum professionals in relation to recent research in visual arts and education? How can interactive arts-based research exhibits challenge the permanent exhibits in museums to reflect more inclusive and diverse portraits of "place?" How can visitors engage in critically meaningful ways by physically involving themselves and inserting their own stories to enhance teaching and learning experiences? (Beer & Grauer, 2011, p. 4)

Their research questions reveal the intent to produce a polyphonous outcome rupturing "the seemingly cohesive and objective narratives of museums," and arguing instead "for a more open-ended and complicated way of dealing with the representation of history" (Beer & Grauer, 2011, p. 7). The researchers accomplished this first by identifying a matrix of community voices, captured in "a video montage of interviews with people" which was titled *Mosaic*, stories designed to "expose visitors to multiple, sometimes oppositional perspectives on the fishing industry" and reflect "the non-linear and artistic approach taken towards researching salmon, the ecological and economic catalyst of many maritime communities" (Beer & Grauer, 2011, p. 4).

The aim was to *reconstruct* and *re-present* these stories utilizing a "situation-specific arts-based" scenario and a transgressive aesthetic approach, altering and disrupting socially accepted narratives about the purpose of museums as social institutions through "the experience of viewing/physically negotiating/performing" within the juxtaposed and overlapping contexts of "interactive, immersive art installations" (Beer & Grauer, 2011, p. 4). Ultimately, this work of art and research enacted a *re-scripting* of lived and local contexts, one that promotes "reflection on the challenges and impacts of social, cultural, and ecological transitions in communities historically dependent on fishing" (Beer & Grauer, 2011, p. 2).

Figure 27. Theorizing local ecology

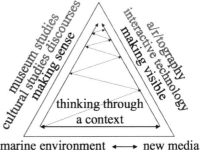

Utilizing an interdisciplinary new media and public pedagogical approach that addresses "cultural and marine environmental sustainability in coastal communities," the collaborating researchers have created "an aesthetic means for contributing diverse perspectives, catching and releasing stories that challenge the seamlessness of those historical narratives typically represented by museum displays" (Beer & Grauer, 2011, p. 2).

Beer and Grauer's critical-activist theory about a local Canadian Pacific coastal ecology as it relates to larger global ecological concerns (See Figure 27) is intended to represent the "the idea of a complex cultural and social history of coastal communities that once relied on salmon and promotes new awareness of environment conditions impacting communities" (Beer & Grauer, 2011, p. 7). The internal validity of this theory is further developed into evidence by a new media method for cultivating stories of interaction within a public environment, which includes the following artworks:

Geoscape, interactive sensor activated sculptures that reference the geological marine environment and mineral nutrition of salmon; Soundposts, interactive sculptures suggesting outdated communication devices and comprised of archival cans producing arduino operated sounds such as those

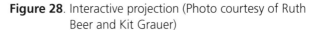

Figure 28. Interactive projection (Photo courtesy of Ruth Beer and Kit Grauer)

heard on fishboats at sea; and *Disrupting Currents,* a large interactive projection, a visualization of audio and scientific data (information on currents, salinity, temperature, oxygen) derived from underwater ocean sensors operated by Canada's research marine observatory located off the west coast of British Columbia, an area traditionally rich in salmon. (Beer & Grauer, 2011, p. 5).

Viewed through the ABR theory-building algorithm T = E ÷ I, Beer and Grauer's lived, acquired, and negotiated experience with museum studies, contemporary art, and a/r/tography first hones in on the data set of their local coastal environment and regional identity, discovering its initial covalence with selected research methodologies for making inherent meaning more visible. Beer and Grauer's *interrogative* theory-building approach was undertaken in the address of a research question about a *biological* need for sustainable and balanced living, first engaged through new media and public pedagogy, and then further mediated by a/r/tographic and immersive interactive technology interpretants. The Social Sciences and Humanities Research Council of Canada generously funded this 2009–2012 project.

Manisha Sharma, a doctoral student at The Ohio State University, presents a theory-building process that begins with the investigation of a *hominological* problem and a primary research question that seeks to interpret and represent human/social properties and phenomena. In this case, Sharma uses the metaphor of *assemblage* as a critical-activist structure for questioning "narratives of Indian art education within a framework of postcolonial-globalization theory and visual culture studies" while overwriting the ontological maps with which we too easily categorize "traditional" art education practice (Sharma, 2011, p. 2). Sharma's (2011) research involves a "case study of art educators located in two urban sites of north and south India" (p. 2); yet her effort to understand the "development of art education in contemporary India," is complicated not only by "a paucity of published writing" on the subject, but by "the complexity of issues concerning the preparation of art teachers in India in the current climate of socio-political and economic change in the country" (p. 3).

> Initiating a dialogue with art teachers in India revealed my use of term "art education" itself to be problematic. While I was talking about art education as a discipline of study and a licensed practice the way I studied it in the west, people I was talking to in India interpreted and used it in different ways. (Sharma, 2011, p. 3)

In order to aid her interrogation of hybrid colonial/postcolonial ontologies and systems for practicing art education, Sharma's decision to draw upon the "Deleuzoguattarian idea of assemblage" allows her to "visualize" her research process and the polyphonic "multiplicity" of disciplinary ways of knowing encompassed in her research theory-building (Sharma, 2011, p. 4). According to Sharma's reading of Deleuze and Guattari (1987), "form or structure of an assemblage of machinic devices cannot be seen or defined [until] its function is

Figure 29. Disrupting the linear

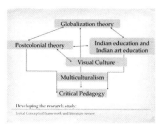

understood" (Sharma, 2011, p. 5). In other words, form is established as a function of *becoming*. Given the array of mutually disruptive directional flows of knowledge between East and West (See Figure 29), what is Indian art education becoming?

In her search for new pedagogical lines of flight, Sharma first viewed her research data set as spatial in nature, involving trajectories of polyphonous discourse moving back and forth across geo-political boundaries. Hence, Sharma asks: "*What pedagogical possibilities for art education emerge in globalization discourses through an analysis of the practices of artist educators in India?*"

My research began as a physical problem, intent on finding curricular possibilities within a deconstructive framework, drawing upon my insider/outsider location as an artist educator and researcher... However, it moved quickly into being a hominological problem as my critical deconstructive framework became restricting, in that it was leading me to un/consciously bestow hierarchies on my Indic and western ways of knowing and to be prescriptive in my presentation of ideas. Perceiving the danger of my contribution to a unidirectional ontological flow from west to east... I turned to Deleuze and Guattari for a rhizomatic rather than arborescent ontology as it resonated with my Hindu/ Vedic worldview. At my current point of analysis of data, I find the research traversing back and forth from the physical to the ideological as, I believe, all good research should do. (Sharma, 2011, p. 4)

Sharma's rhizomatic conception is crucial to her research, part of a theory-building process that she claims has "blurred and disrupted an arborescent understanding of my Indic philosophical roots that have branched into 'westernized' theories and practice"; meanwhile, the hybrid points of genesis inherent within a rhizome has allowed Sharma to visualize a "hybrid ontology" helping her to be able to "see and present a more evenly directional flow of knowledge not only between east and west, but also within the different layers of narratives the research involves" (Sharma, 2011, p. 6).

In order to address her primary question, Sharma proposes a critical-activist arts-based theory architecture that interrogates case studies of educators across boundaries of practice, deconstructs disciplinary boundaries, and reincarnates pedagogical possibilities within postcolonial and globalization discourses—*thinking through an assemblage of regenerative narratives surrounding Indian art education*. In doing so, the researcher asks: "1) What does this study tell us about the role and potential of art education in India within a postcolonial, globalization discourse? 2) What do these narratives tell us about the developing identity of contemporary Indian art educators and Indian art education? 3) What does this study tell us about the development of visual

Figure 30. Theorizing Indian art education

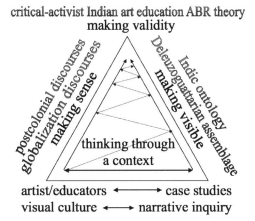

culture and art education in contemporary India?" (Sharma, 2011, pp. 3, 4)

To further build upon these questions, Sharma is interviewing teachers "across disciplinary striations of museum, school, college, community, fine art, craft and design," while navigating nomadic spaces of "language, geography, politics and cultural background" in order to reveal narratives of "feminism, multiculturalism, and intellectual colonization in globalization discourses that emerged, overlapped and became re-positioned" (Sharma, 2011, p. 4). Pursuing the interrogation and reinterpretation of discourses that contextualize the lives of Indian art educators, Sharma also actively confronts "troublesome definitions of terms like *tradition* and *authenticity* in theory and practice" in her effort to articulate new pedagogical possibilities (Sharma, 2011, p. 4, emphasis added). However, given the rich history of Hindu mythological contexts through which they must inevitably arise, any incarnation of new pedagogical possibilities pertaining to Indian art education may be viewed, more aptly, as a reincarnation. Sharma explains as follows:

> ...I find the idea of reincarnation, a basic Hindu belief, parallel to Deleuze's notion of difference and repetition...both iterate that things move in patterns, returning and repeating but not identically–each cycle of events has some difference be it growth or regression. It is in focusing on this difference and repetition that opportunities for learning and change can happen...The concept of *karma* is no different. One might not know, initially, where the practice or practitioner is headed—it is only through the consciousness of building up a consistent and sustainable practice that one finds the meaning of the practice, the truth of being—or in Deleuzian terms, becoming. (Sharma, 2011, p. 5)

Utilizing a critical case study approach that seeks "articulate Indic ways of knowing in terms of western academic training," this arts-based researcher

embraces the reincarnation of narratives of arts pedagogy and practice (Sharma, 2011, p. 5). In her approach to this research, each narrative emerges "as a cluster of readings that transverse and overlap each other without a hierarchical ordering" (Sharma, 2011, p. 6). Sharma's critical-activist theory-building about Indian art education is intended to "de-center" what she terms as "comfortably rooted ways of knowing" in order to "engage with the idea of tradition and culture as evolving rather than rooted in a static interpretation of the past" (Sharma, 2011, p. 6).

Viewed through the ABR theory-building algorithm $T = E \div I$, Sharma's lived, acquired, and negotiated experience as an arts educator of Indian descent completing her Western academic training first hones in on the data set of artists and educators currently living in India, documenting narratives of their teaching philosophies and methodologies along with evidence of the same as found in Indian visual culture. Discovering the initial covalence of those identities with selected methodologies for making their meaningfulness visible, Sharma's *interrogative* theory-building approach is undertaken in the address of a research question about how to map the *hominological* phenomena of pedagogical theory and practice in contemporary Indian art education; first engaged through case studies and narrative inquiry, Sharma's research is then further mediated by Indic ontology and rhizomatically assemblaged interpretants.

How to Write a Critical-Activist Arts-Based Research Paper

Writing a research paper utilizing a critical-activist arts-based method involves thinking and learning interrogatively, actively transforming prior knowledge by challenging it. In my 2011 research article "Circumventing the Imposed Ceiling: Art Education as Resistance Narrative," I contested the homi-

nological problem of an all too common misunder-
standing displayed by policy-makers about the au-
thentic purpose of the arts in learning or of how
best to support it (Rolling, 2011); however, my ad-
dress of this problem began with the effort to ad-
dress the *physical* problem of an ill-conceived ceiling
in a school art studio. This contestation was accom-
plished through the vehicle of a narrative about
active resistance against a powerful school bureau-
cracy, a narrative that in itself was also an inten-
tional digression from the way research is typically
done. The question at the center of my inquiry was:
What are the implications of stories from the mar-
gins of consideration, stories that erode the center
and its certainties—stories that cause institutional
grand narratives to fall apart?

My interest in this problem stemmed from a per-
sistent reality—art education continues to be prac-
ticed in the thrall of a scientific paradigm that
misunderstands the greater potential of the arts in
education, often imposing a ceiling ill-fitted for arts
praxis, arts-based research, or arts pedagogy. The ar-
ticle tells the story of how the art studio quickly be-
came a marginalized space even while functioning
as one of the centerpieces of a new educational en-
terprise, and yet how working actively from those
margins can become a strategy for yielding a surrep-
titious and insurrectionary counter-story circum-
venting all marginalization.

In this research paper, I utilized an critical-activist
arts-based research approach to tell the story of an
imposed ceiling—a problematic exposed ceiling
physically constructed above the 5th floor art studio
where I taught my classes in a newly constructed
school building located at 556 West 110th Street.
Since our school building was built from the ground
up in preparation of our launch in September of
2003, the floor plans and room layouts were config-
ured long before any of the faculty was hired—none
of the visual arts teaching team was fully consulted
on the architecture of our assigned space. Hence, our
art studio was situated beneath a vast and convo-

luted exposed ceiling intended to be a showcase on the journeys of visiting educators and parents through our school. Ventilation ducts in the ceiling's design, assorted tubes and pipes, and even telephone wire bundles were all left visible as an architectural novelty, primarily to titillate visiting parents and teachers on their regular whistle-stop tours.

However, in the everyday use of the art studio space, the students themselves rarely paid much attention to the ceiling—even so, the acoustic conditions in the space ceaselessly interfered with teaching and learning. None of the walls within the perimeter of the double-height space actually reached the ceiling, and there were metallic sheaths and other hard surface areas in many places that amplified each raised voice, every bounding footstep, and each awkward shift of stool legs across the floor. These interruptions were compounded by the fact that the art studio was designed so that three art classes could be scheduled to use it simultaneously; even if only two different classes were scheduled to use the art studio at the same time, the noise level was amplified to the point of being a constant distraction to focused learning. The architects also designed our floor so that the only route to the music room was through the art studio; that route went right in front of the Smart board presentation technology in the main discussion area! In the midst of this incessant din and distraction, youngsters with already short attention spans asked us to repeat instructions simply because they could not hear.

But there was more to the story of our school—which, in fact, was somewhat pretentiously named *The School*. According to our new institution's publicity and internal handbooks, the administrators and creators of our school wanted very much to position our brand as a center of modern educational innovation and reform, its faculty corroborating what its grandiose name communicated—that *The School* stood as a laboratory that would generate important new solutions to the difficult problems involved in providing the most equitable and effective

education for all. Yet, I was one of several faculty members who actively resisted this storyline based on our school's collective inability first to adequately solve the most glaring problem at hand—an administration that was either not willing or able to engage in authentic dialogue with its own faculty toward improving teaching conditions, morale, and a safe working climate of mutual respect.

My writing built up a theory that more than just a physical ceiling had been imposed on us in the art studio. We, the four art teachers charged with using that space as our primary teaching arena, had asked repeatedly over much of the two years I was on staff that our school administrators support our teaching by hanging a lowered ceiling of acoustic tiles, rather than sacrificing the ability of our students to focus on lesson discussions for the sake of a fanciful appearance. Our pleas for help were addressed with half measures that did nothing to abate the acoustical disruptions. Even when our pleas became demands, it remained clear our needs were not being prioritized. Not only was the physical learning environment ill-fitted in this case—so was the stance of the school administration regarding the professional recommendations of its visual arts faculty. The imposition of a ceiling described in this story is not presented primarily as an indictment, but rather as a metaphor representing the recurring ill-fittedness of the arts within modern educational ventures based upon curriculum rationales and learning taxonomies like those introduced by Ralph Tyler and Benjamin Bloom, one of Tyler's protégés.

> The scientific and institutionalized belief systems that build taxonomical models in education present a monumental and oppressive structure that too easily occludes those educational stories that emerge from the margins, stories that disrupt the central or centering storyline . . . I tell the story of the imposed ceiling not to suggest the destruction of all taxonomical structures, but to contest that the labyrinthian burrows which serve to under-

mine taxonomical pedagogies are *also* necessary structures—poststructural encroachments uncoiling from ontological borderlands to unsettle our deeply held certainties, post-structures that come into being mainly as the result of displacements rather than placements... (Rolling, 2011, p. 103)

The research article concludes as a representation of how the ex-centricity of arts-based educational practices opens up a "pedagogy of possibility" recognizing that the continuum of learning often starts in the margins of curricular plans and expectations. I began to tell this counter-story while I was still employed as an art teacher by *The School*, a decision that I felt put my job at considerable risk. But I suffered no such loss; instead I entered and continue to navigate a labyrinth of curricular possibilities. The imposed ceiling became instead an anomalous pathway for my own learning and professional development, and in this writing, an anomalous pathway for educational research.

Critical-Activist Arts-Based Curriculum-making Strategies for Educational Practice

Critical-activist art-making practices are interrogative strategies for learning—constituting arts-based bodies of knowledge "through" the renegotiation of situated understandings. Critical-activist arts-based curriculum-making recognizes *Thinking Through a Context* as a viable exercise in learning behavior. Interrogation becomes a methodology for meaning-making—and contested ideas become the site of research or student learning. Critical-activist art-making practices yield at least the following strategies for classroom learning, with more to be named by others.

Montage is a process or technique of selecting, editing, and piecing together separate sections of film to form a continuous whole. Conceptual montage is a critical-activist research and teaching/

Conceptual Montage

A critical-activist research and teaching/learning strategy generating the (re)contextualization of knowledge through the archaeology, defragmentation and reassembly of previously disconnected meanings.

learning strategy generating the (re)contextu-alization of knowledge through the archaeology, defragmentation and reassembly of previously disconnected symbols, artifacts, ideas, and remain-ders. Ida Applebroog is an artist who employs con-ceptual montage. Applebroog has explored themes of gender, sexuality, power, politics, the role of the mass media and domestic violence for nearly half a century. She has excavated archaeologies of pop cul-tural schemata, defragmenting them into a theater of simplified and boldly outlined human forms, "everyman" figures, anthropomorphized animals, and cryptic characters that are half human and half creature. Applebroog has also converted her paint-ings and drawings into installations by montaging canvases in space, translating the sequential logic of comic and film narratives into three-dimensional environments. Applebroog often montages imagery from recognizable everyday urban and domestic scenes, at times also pairing them with texts and creating artists' books.

Shahzia Sikander is another artist who employs conceptual montage in her art-making practices. The following excerpt from the Art21 PBS website of-fers insights into Sikander's exploration of separate aspects of her cultural experience, montaging them into a continuous whole:

Sikander specializes in Indian and Persian miniature painting, a traditional style that is both highly styl-ized and disciplined. While becoming an expert in this technique-driven, often impersonal art form, she imbued it with a personal context and history, blending the Eastern focus on precision and methodology with a Western emphasis on creative, subjective expression. In doing so, Sikander trans-ported miniature painting into the realm of con-temporary art. Raised as a Muslim, Sikander is also interested in exploring both sides of the Hindu and Muslim "border," often combining imagery from both—such as the Muslim veil and the Hindu multi-armed goddess—in a single painting. Sikander has

written: "Such juxtaposing and mixing of Hindu and Muslim iconography is a parallel to the entanglement of histories of India and Pakistan." (Retrieved February 11, 2012 from http://www.pbs.org/art21/artists/shahzia-sikander)

Collage is a form of art in which various materials such as photographs and pieces of paper or fabric are assembled, composed and attached to a common background. Conceptual collage is a critical-activist research and teaching/learning strategy generating the (re)contextualization of knowledge through the rendering of new stances and conditions that contend with extant symbols, artifacts, ideas, and remainders. Mark Dion is an artist who employs conceptual collage. Dion's work often collages scientific methods and subjective influences in works that are reminiscent of the curiosity cabinets that were once prevalent throughout Western Europe. But rather than touting an authoritative Eurocentric and scientific worldview, Dion's work is intended to contest with the containments often placed around what makes for useful knowledge content—recontextualizing dominant ideologies and public institutions within background panes of new and unexpected aesthetic experiential encounters. Dion's conceptual collages thus reshape our understandings of history, prevailing theories, and the natural world.

Doris Salcedo is another artist who employs conceptual collage in her art-making practices. The following excerpt from the Art21 PBS website offers insights into Salcedo's collaging of art and engineering, social memory and the present, in addition to themes of power and impotence:

> Salcedo's understated sculptures and installations embody the silenced lives of the marginalized, from individual victims of violence to the disempowered of the Third World. Although elegiac in tone, her works are not memorials: Salcedo concretizes absence, oppression, and the gap between the disempowered and powerful. While abstract in form and

Conceptual Collage

A critical-activist research and teaching/learning strategy generating the (re)contextualization of knowledge through the rendering of new stances and conditions that contend with extant meaning.

open to interpretation, her works serve as testimonies on behalf of both victims and perpetrators. Even when monumental in scale, her installations achieve a degree of imperceptibility—receding into a wall, burrowed into the ground, or lasting for only a short time. Salcedo's work reflects a collective effort and close collaboration with a team of architects, engineers, and assistants—and, as Salcedo says, "with the victims of the senseless and brutal acts" to which her work refers. (Retrieved February 11, 2012 from http://www.pbs.org/art21/artists/doris-salcedo)

Conceptual Bricolage

A critical-activist research and teaching/learning strategy generating the (re)contextualization of knowledge through appropriation, assimilation, and reconfigured applications of available meaning.

Bricolage is a process involving the construction or creation of a work from a diverse range of things that happen to be available. Conceptual bricolage is a critical-activist research and teaching/learning strategy generating the (re)contextualization of knowledge through the appropriation, assimilation, and reconfigured application of available symbols, artifacts, ideas, and remainders. Mel Chin is an artist who employs conceptual bricolage. Chin's work is difficult to classify, both poetic and analytical, a bricolage of concepts from unlikely and often unrelated disciplines such as alchemy, botany, ecology, and engineering. Chin insinuates this artwork into destroyed homes, toxic landfills, and even popular television, reconceptualizing art-making as *art for society's sake* in order to provoke greater social awareness, responsibility and to help rejuvenate the economies of inner-city neighborhoods like the one Chin grew up in.

Michael Ray Charles also employs conceptual bricolage in his art-making practices. The following excerpt from the Art21 PBS website offers insights into Charles' unique art practice bricolaging the beautiful and the ugly, nostalgia and stereotype, into works portraying the postmodern identity of African Americans:

His graphically styled paintings investigate racial stereotypes drawn from a history of American ad-

vertising, product packaging, billboards, radio jingles, and television commercials. Charles draws comparisons between Sambo, Mammy, and minstrel images of an earlier era and contemporary mass-media portrayals of black youths, celebrities, and athletes—images he sees as a constant in the American subconscious. "Stereotypes have evolved," he notes. "I'm trying to deal with present and past stereotypes in the context of today's society." Caricatures of African-American experience, such as Aunt Jemima, are represented in Charles's work as ordinary depictions of blackness, yet are stripped of the benign aura that lends them an often-unquestioned appearance of truth. (Retrieved February 11, 2012 from http://www.pbs.org/art21/artists/michael-ray-charles)

An example of a critical-activist teaching/learning strategy successfully elicited through the art education curriculum is a political cartooning exercise undertaken by a group of 4th graders while examining the theme of social justice (Rolling, 2008b). When the 4th grade-level teaching team at my former school all agreed on a third trimester theme of Social Justice one year, I became interested in viewing the opinions of my students both on matters we had been talking about in our classrooms and also on matters important to them which were invisible to me. Since we were still in the wake of the 2004 presidential election and the buzz of conversation about the candidates amongst the children and families at home and at school, I proposed the idea of having each student create his or her own political cartoon.

I explained a political cartoon to be a commentary on current events that expresses an opinion and serves to persuade others by its appearance in the public conversation. I further explained that political cartoons are drawings representing current public figures or important social issues symbolically and often satirically, and that art was very much about the ideas my students thought were important. As an alliance at the start of this unit, I

asked Jules Feiffer—a syndicated and Pulitzer Prize winning cartoonist for *The Village Voice* who is the parent of one of my students at that time—if he could come in and give a talk about the process and development of a political cartoon from early sketches in stages all the way to final product. I filmed his talk in the school library to share with students who could not be present.

My conception of this political cartooning project depended a great deal on my conception of my job as a teacher—to open the pedagogical space for students to be as critical, as perspicacious, and opinionated as they chose to be. So, as a precursor to their political cartooning exercise, I asked each 4th grader to name and pictorialize an injustice in the world today that he or she wanted to help make better. In doing so, I was also asking each student to draw out into the open and unpack opinions rooted in mind, apart from any intervention from me as their teacher on how to best represent their thinking. I wanted to see what ideas students had already consumed from general media awareness or family discussions, or generated in private thought, and how those ideas had catalyzed their critical awareness.

In one sketch, a youngster named Ian represented his affection and concern for wild animals as their space is being invaded. In the color pencil drawing, those who wield weapons and hunt for sport also cause the home of these forest creatures to be engulfed in flames. In a follow-up drawing, Ian expressed what needed to be done to establish a new order where, under the watchful eye of animals, men hose down the conflagration they have ignited. The forest animals take on the power and agency to resist the encroachments of humans. In the lower right-hand corner, as a wild spotted cat speeds to overtake what will likely be its next meal, one notes that even in the midst of the more obvious focal point of this spectacle, other important transactions are taking place. Ian sees life unfolding. Do we, as teachers, value the critical lives of our youngest students?

Ian's anatomically and proportionally correct renderings of these animals were evidence of strong visual culture interests in observing nature, nature photography, nature media programming, possessing the strong characterizations one might find in a Hollywood animated film featuring creatures of the wild. In early sketches for Ian's final political cartoon, one views a large spotted cat in a position of domain authority looking down from a tree branch and confronting a man holding a chainsaw with the words "What are you doing?" depicted in a speech bubble. Coincidentally, this drawing also characterizes the willingness of educators to undercut what students already know how to do and are familiar with in deference to the industry of public schooling. We recklessly clear-cut the untamed growth of individual interests and self-directed invention germinating from student lives in favor of more predictable classroom assignments—thus denuding the curricular landscape of opportunities for each student to develop a personal agency that grows without need for our incessant teacherly interventions.

In Ian's later drawings, we view the position of the same large cat as validated by a diversity of animals, now presenting a representative majority in opposition to the lone man with the chainsaw—while the cat's cubs, arrayed with black belts, noisily practice their martial arts repertoire of kicks and punches, shattering wooden boards in the tree's protective canopy. When we finally view Ian's finished cartoon, titled "Stay Away From The Tree," the dialogue from one of the cubs in the tree has changed from the posturing statement, "Don't make me come down there!" to the more confident, "Can we get the man with the chainsaw?" in the final pen and ink rendering. This project was prompted by conceptual montage as an art-making and learning methodology, piecing together facts and reflective critical judgments about those facts into a continuous whole—an informed opinion in the shape of a political cartoon. Critical-activist approaches to art education practice open up possibil-

ities for youngsters to imagine their responsibilities as citizens at an early age.

Glossary

Conceptual Bricolage—A critical-activist research and teaching/learning strategy generating the (re)contextualization of knowledge through appropriation, assimilation, and reconfigured applications of available meaning.

Conceptual Collage—A critical-activist research and teaching/learning strategy generating the (re)contextualization of knowledge through the rendering of new stances and conditions that contend with extant meaning.

Conceptual Montage—A critical-activist research and teaching/learning strategy generating the (re)contextualization of knowledge through the archaeology, defragmentation and reassembly of previously disconnected meanings.

Critical-Activist Arts-Based Curriculum-making Strategy—A curriculum-making strategy for the arts and design in education that involves *thinking through a context*, wherein interrogated and contested ideas become the site of research or student learning.

Ex-centric—An ex-centric approach to research allows for the displacement of privileging ontological and epistemological assumptions away from a central locus of validity and toward the margins of our perceptions.

Arts-Based Research as Improvisatory Research Practice

Postmodern Precedents for an Improvisatory Arts-Based Inquiry Architecture

Reflexivity
An approach to generating improvisatory ABR research outcomes through idiosyncratic methods for making meaning and recording knowledge.

The ambiguities and vagaries of the postmodern era problematize the authenticity of the unified voice that tells of an essential self. Reflexivity is required to make sense of identity that is derivative of the new century's percolating cauldron of visual cultural imagery, colliding social scripts, virtual texts and lived experience.

Juliet Perumal (2006) describes the essentialist conception of self manifested in at least two ways: as a single axis identity absent of simultaneous axes, "as if being South African Indian . . . were entirely separable from being a woman," and as a supposedly unitary and internally homogenous identity absent of internal subdivisions, "thus erasing the capacity for internal dialogicality" (p. 730). However, drawing upon feminist and poststructuralist discourses, Perumal argues for the necessity to prob-

lematize the complex of contemporary identity. Postmodernist assumptions view the contemporary identity construct as "a multiplicity of ironic and conflicting interdependent voices that can only be understood contextually, ironically, relationally, and politically" (Slattery, 2001, p. 374). The strategy for attaining this understanding requires reflexivity in interpretation.

Postmodern identity is an amalgamation, a meta-symbol through which we construct and re-construct our version of the world. Perumal eluci-dates two identity-making processes described by Mary Bucholtz (1999) that are particularly relevant to the discussion of an improvisatory arts-based the-ory architecture.

> *Identity as invention* makes visible the often invisible process of identity construction. It refutes the belief that identities are given in advance for individuals to step into, and posits that identities are in-vented/produced in interaction, through processes of contestation and collaboration, and they may be simultaneously . . . *Identity as improvisation* sug-gests that new social arrangements provide the means to shape new identities. Often individuals employ resources in ways that cannot be pre-dicted in advance. Through the innovative re-working of previously formulated structures, they transcend deterministic frameworks of identity, demonstrating through their actions that identity is instead a continuous creative practice. (Peru-mal, 2006, p. 733)

Intertextual

Intertextuality refers to a system of colliding interrelationships between the individual psyche, society, and the world that renders individual and social identity impossible to delimit or pin down.

Postmodern identity, as a meta-symbol, is also then *intertextual*, requiring reflexivity to suss out the relationship of all the texts that comprise it. How-ever, the texts that constitute an identity today can be irrevocably altered by tomorrow. According to Julia Kristeva, "a text works by absorbing and de-stroying at the same time the other texts of the in-tertextual space" (cited in Marshall, 1992, p. 130). This continual flux and ferment of textual debris

renders identity impossible to delimit or pin down . . . and yet we find individual and social identity at the center of most every enactment or reenactment of knowledge.

So how then do we do research around identity? What kind of cartography is adequate when the boundaries of a phenomenon keep shifting? Reflexivity in research methods takes a full and ongoing account of the self and the effect of the identity and presence of the researcher upon what is being investigated. Whereas the mantra of the scientific method is said to be *objectivity* and a purported *absence of bias*, the mantra of arts-based methods may be exemplified as *reflexivity* and the *active negotiation of one's multiple biases and perspectives* in meaning-making endeavors. Such reflexivity is also necessarily improvisatory—intuitive, ephemeral, and often autonomic in nature—proceeding "from everything we know and everything we are," converging upon any given stimulus or focus of inquiry "from a rich plurality of directions and sources" (Nachmanovitch, 1990, p. 40).

Improvisatory Arts-Based Curriculum-making Strategy

A curriculum-making strategy for the arts and design in education that involves thinking reflexively, wherein the self becomes both the site and an instrument of research or student learning.

Thus, and perhaps most controversially, arts-based methods may range from the purely instinctual and unconscious, to the fully cognitive. Between these two distinct modalities of knowing lies the intuitive, defined as that "which allows us to escape the inflexible world of instinct by mixing unlike entities," relying neither on inexplicable precognitive impulses or careful logic but on that which is wholly and simultaneously "inventive and unreasonable" (Wilson, 1998, p. 31). This range of instinctual, intuitive, and fully cognitive modalities are all at play in the creation of new knowledge through improvisatory arts-based research.

In the following example of arts-based research, Dr. Wade Tillett presents a theory-building process that began with the investigation of a *hominological* problem and a primary research question that sought to interpret and represent human/social properties and phenomena. In this case, Tillett examined the acts involved in selecting a curriculum—

that is, a pathway for the multitude of "interventions and sustainments" required to navigate and negotiate life in what Tillett (2011a) has identified as *the urgent present* (p. 142). Tillett explored how we each, as learners, change the way we think "moment-by-moment as we live our daily lives . . . in the continual micro-decisions of living" (Tillett, 2011b, p. 2).

Tillett, a former architect and currently Assistant Professor for the Department of Curriculum & Instruction at the University of Wisconsin - Whitewater, began his improvisatory exploration by asking the simplest question: *How to live?* This question is an evocation of John Dewey's definition of education as the modification of experience—both to add to its meaning and to facilitate its further modification or theorizability. According to Dewey, education is "formally summed up in the idea of continuous reconstruction of experience" (Dewey, 1916/2005, p. 49). The understanding that education is manifested as the continuous building of theories of experience also echoes one of the main premises of this *Primer*—that theory-building in research requires approaches as *diverse* as our local life experiences.

> Being that research is necessarily an act of selection within my life, I conceived research as a tool of modification, as necessarily performative. Like learning to draw is a way of learning to see, I hoped that researching my life would help me to live. By looking at the seemingly inconsequential and unintentional, I hoped to unearth the unspoken theories that govern them and act with more intention and consequence. (Tillett, 2011b, p. 5)

In his approach to theory-building, Tillett (2011a) opted for the "under-construction sort of format" that has a wide array of precedents in "performance art, architecture, poetry, film, qualitative research, and curriculum studies" (p. 22). A performative methodology is also inherently intuitive, involving "nondiscursive modes beyond the written process and product" (Tillett, 2011a, p. xv).

Tillett's research proceeded to situate itself within a curriculum studies ontology that views curriculum as a verb, not a noun, seeking to move contemporary discourses on education "beyond the walls of the school building to include all aspects of life" (2011a, p. 5). To address fundamental questions about how life is lived and changed requires a method of inquiry that is reflexive.

> For my purposes, I define curriculum as the act of selection. I put my focus on curriculum as a verb more than a noun, on the act of selecting more than the selected, on the how more than the what, on the question more than the answer.
> A (re)search is a self-conscious exploration.
> A (re)search of curriculum then, is a self-conscious exploration of the act of selection, an attempt to self- consciously select. (Tillett, 2011a, p. 5)

The intertextual, multimodal, multi-voice nature of this type of improvisation is borne out in the construction of Tillett's dissertation itself, "a variation on the 'multi-paper dissertation'—a collection of independently publishable articles," including "not only papers, but snippets, interludes or other

Figure 31. "Textual Explorations Book 1" was a modified romance novel that explored overwriting, selection, deletion, and text modifications expanding beyond the discursive level. (Photo courtesy of Wade Tillett)

interruptions and juxtapositions" (Tillett, 2011a, p. 24). This arts-based researcher thus set out to explore "the action of curriculum," juxtaposing contradictory and coincidental texts in an attempt "to portray the operations of the research on context and context on research" (Tillett, 2011b, p. 2). In order to address his primary question, Tillett (2011a) has fabricated an improvisatory method "inhabiting the interstices" between self, other, and social research (p. 37)—*thinking reflexively about the dynamic relationship between ambiguity and possibility, for life's sake.* Embedded within this research are other implicit questions: *"How am I living? From broad contexts of power to the micro-politics of the unremarkable, what creates the curriculum of my life? What are the acts of selection? What determines those acts?"* (Tillett, 2011b, p. 3, emphasis added). Tillett describes his writing method as follows:

> If I have a clear outline in my head about what I am going to say then the project is uninteresting and usually remains unwritten. Instead, I ramble and search and repeat themes and when I feel like I am starting to get somewhere, when there is some sort of breakthrough, I go back and I edit and edit. I cut and paste all the different things into some sort of order; because my rambling thoughts don't go in order. Sometimes at this point I lose interest because what was a building variety becomes boring and linear. But no one else wants to read this sort of rambling, I don't think. Anyway, if I'm lucky I can keep editing until it actually becomes a fully developed thought. The trick to writing (for me) is to go back and follow these troubling little fractures. Yes, I want to resolve them. I want to learn where they lead. (Tillett, 2011a, p. 37)

Utilizing a jump cut montage approach to piecing together methods "related to community or participant based research, action research, teacher research, and autoethnography," Tillett methodically shapes an improvisation that "attempts to place

Figure 32. Theorizing life curriculum

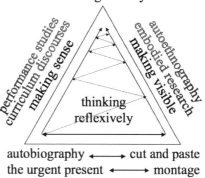

improvisatory life curriculum ABR theory
making validity

autobiography ←——→ cut and paste
the urgent present ←——→ montage

the reader in a position in which s/he feels compelled by gaps to act and create her or his own personal meaning" (Tillett, 2011a, p. 21). His dissertation is structured in four sections, "organized around the ideas of modes and methods of embodied research, school as a contested social space, architecture as a structuring of daily relations, and living as a spiritual-aesthetic practice" (Tillett, 2011b, p. 2).

Tillett's improvisatory theory about life curriculum (See Figure 32) is innately combinatory and intended to represent the "multiple modes of living" through a collision of "full-length articles, short descriptions of activities, photographs, proposals, prescriptions, and poems" (Tillett, 2011b, p. 6). The internal validity of this theory is further evidenced by the emergent process and product of Tillett's efforts—a dissertation representing one of many possible curricula for daily life, embedded and revealed within the theoretical architecture.

Combinatory

An improvisatory ABR research outcome intended to represent the multiple modes of an experience and multiple strategies for theory-building all at once.

In writing about the curricula of daily life, I must assume that the intervention, the effects, of this research will be situated in a life different from my own. Thus my research becomes pedagogical. I write to teach. I do not intend to arrive at answers, but rather to open areas of inquiry and look down possible paths that both myself and my imagined reader might take up. I have not tried to find univer-

sal frames or obligatory inquiries, but to dive into a context enough to unearth and open up questions, or better yet—modes of questioning, that you might want to take up in your own life. I have not tried to convey findings, but to look for possible answers enough that I can share a few potential tools you might want to use, with modifications of course, in your specific contexts. "How to live," after all, is best left as a question. (Tillett, 2011a, p. 195)

Viewed through the ABR theory-building algorithm T = E ÷ I, Tillett's embodied, acquired, and negotiated experiences as a human being first hones in on the data set of his own autobiography and its living contexts within *the urgent present*, discovering its initial covalence with selected methodologies for making inherent meaning more visible. Tillett's reflexive theory-building approach was undertaken in the address of a research question about the *hominological* imperative never to cease asking oneself how to live, first engaged through an intuitive, cut and paste approach to telling personal stories and a montage approach to documentation, and then further mediated by autoethnographic and embodied research interpretants.

Laura Lee McCartney, a doctoral student at the University of North Texas, presents a theory-building process that begins with the investigation of a *physical* problem and a primary research question that seeks to interpret and represent material/object properties and phenomena—in this case, the curation of transient identity constructs in clutter and cloth as an analogy for the creation of curriculum.

Curate derives from the Latin *curare*; to care, to guard, or to protect. Curating is characterized by the processes of selecting, organizing, and protecting the items in a collection or exhibition. (McCartney, 2011, p. 2)

McCartney has adopted the perspective that "curriculum is not fixed but an action, or *currere*, the Latin word meaning to run with, to run on a course" and therefore—looking for the "similarities between *curare* and *currere*"—she inquires what it might mean "to run on a [theory-building] course as a curator, and what might those actions mean to curricula" (McCartney, 2011, p. 3). But McCartney's improvisation does not stop there. McCartney endeavors to reengineer the genetic material of the ubiquitous new methodology called a/r/tography as she pursues a research question that requires methods yet unnamed. McCartney's research "allows for the possibilities of adding a 'c' for 'curator' beside and between the slashes of 'a/r/tography' to create another acronym 'c/a/r/tography' where curator/artist/researcher/teacher identities might converge and diverge and allow for self mapping" (McCartney, 2011, p. 2). And since her research is also investigating the "connections between curating and curriculum development," the letter "c" likewise insinuates itself as a symbol for "curriculum" (McCartney, 2011, p. 3).

> What might it mean to "care for" and "run with" curricula as artist/researcher/teacher? If curriculum is an autobiographical act, where educators bring their histories and values to their teaching, and pass that along to their students, then what might my autobiography mean to art education and curriculum and pedagogy where *curare* and *currere* be voiced? As I unpack my curatorial knowing, I realize I have to look backwards before I can look forwards, I have to deal with the clutter and collecting that shaped my curator beginnings and the ways I select, care for, and discard materials in my teaching. (McCartney, 2011, p. 3)

Through this methodology, McCartney has begun to build a reflexive *and* ad hoc theory architecture that she personally claims will be "situated

Figure 33. Mapping the Turns (installation images from the
Texas Fashion Collection exhibition, Haute Cou-
ture: The Great Paris Designers, curated by Laura
Lee Utz McCartney, 2000

in my public and private curatorial and teaching
spaces, as I look back and look forward, through my
own autobiography for the purpose of exploring my
relationship to my mother, my daughter, and my
clothing collection, and the possibilities such work
opens up for the field of art education—an art edu-
cation that pulls back the curtain on how we collect
and curate curriculum based on autobiographical
and aesthetic priorities" (McCartney, 2011, pp. 3–4).

The metaphor of curation becomes a physical
tool for improvising poststructural and rhizomatic
mappings detailing "where curator/artist/re-
searcher/teacher identities . . . converge and diverge"
within a researcher's "re-presentations of self and
practice" during this postmodern era (McCartney,
2011, p. 5). C/a/r/tographic research asks the reader
to consider: "*What are curatorial ways of knowing and
being?*" (McCartney, 2011, p. 2, emphasis added).

> I plan to journal, recall events, make connections,
> gather artifacts, and contextualize and recontextu-
> alize texts, autobiography, and clothing for new
> understandings and meanings . . . In these render-
> ings, I will curate material culture, where inter-
> woven in the curating, as a curative process, will be

sites of performativity, allowing me to create the-
matic maps of my identity as a curator and as the
mother of a special needs child. My dissertation
may take the form of a curated life, a catalogue of
autobiographical texts, where I might turn inward
to looking at my own collections, to curate Self.
(McCartney, 2011, p. 5)

McCartney thus sets out to explore the perfor-
mativity inherent in the curatorial process of doing
and undoing our collective artist, researcher, and
teacher identities within our postmodern era. In
order to address her primary question, McCartney
(2011) proposes an improvisatory arts-based theory
architecture that maps, un-maps, and re-maps cur-
riculum, "selecting some elements and discarding
others to create new ways of experiencing and see-
ing material" for living (p. 3)—*thinking reflexively
about the material for fashioning a contemporary iden-
tity situated in the seams between curating, curriculum,
and pedagogy*. Along the way, proposed research
questions will include: "How might curator as
artist/researcher/teacher be unpacked, undone, and
rendered through a/r/tographic inquiry? What
might autobiographical curating mean for curricu-
lum and pedagogy in art education?" (McCartney,
2011, p. 3).
 Utilizing a c/a/r/tographic and material culture
approach that reimagines the role of the curator as
a "a site for dialogue, discourse, and critique," Mc-
Cartney—through positioning and repositioning
her own identities as "curator, artist, researcher,
teacher, daughter, and mother"—also problema-
tizes traditional conceptions of how curriculum is
selected and settled upon in public education (Mc-
Cartney, 2011, p. 2). McCartney's improvisatory
theory-building about curator/curriculum-maker
identity is innately combinatory, intended to
reimagine the intersectional life histories of the
artist/researcher/teacher and "to re-present those
histories in image, objects, reflections, interpreta-
tions, and actions" (McCartney, 2011, p. 5).

Figure 34. Theorizing c/a/r/tography

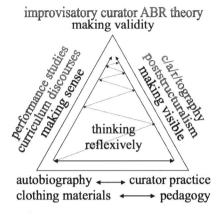

improvisatory curator ABR theory
making validity

autobiography ←→ curator practice
clothing materials ←→ pedagogy

Viewed through the ABR theory-building algorithm $T = E \div I$, McCartney's lived, acquired, and negotiated experience as a curator, artist, researcher, teacher, daughter, and the mother of a special needs child first hones in on the data set of her own autobiography and clothing collection, discovering the initial covalence of those identities with certain methodologies for making their meaningfulness visible. McCartney's *ad hoc* theory-building approach is undertaken in the address of a research question about the *hominological* imperative to teach a living curriculum, first engaged through curator practice and teaching pedagogy, and then further mediated by poststructural c/a/r/tographic interpretants.

How to Write an Improvisatory Arts-Based Research Paper

Writing a research paper utilizing an improvisational arts-based method involves thinking and learning reflexively, reincarnating past and present knowledge into the shape of future questions. In my 2003 dissertation, "Un-naming the Story: The Poststructuralist Repositioning of African-American Identity in Western Visual Culture," I sought to improvise a way to write a dissertation intended as an

exemplar of the continual self-renewal of idiosyncratic identity within a Western society rife with rigidly constructed social norms. This was in an effort to address the hominological problem of social stigma. The question at the center of my inquiry was: *For those who have been named ugly or misfit—for those vilified as the denizens of lesser physical bodies, lesser bodies of knowledge, and bodies lesser-than-normal—what has been the agency for undoing the normative social texts that have ferociously named us?*

This dissertation was born out of three fears, each one reared along with me in a nexus of socially and institutionally unvalorized positions: as an African American male, an artist, and an emerging scholar uncertain of his methodological voice— these being the truest limits of my research, the contexts that most impinged upon the process of actually carrying out this particular study. Most overwhelming was the long-standing fear of my own inadequacy, the fear innate to all black men that we will not be allowed the opportunity to make a difference—that we will summarily be sent to the side entrances. In order to address the fear of my inadequacy as an African American male researcher, this research created a methodology generating the kind of narrative that sociologist Laurel Richardson has described as "a collective story," one giving voice to those marginalized or silenced as sociologically constructed within the prevailing story of Western progress (Richardson, 1997, p. 32).

My second fear and limitation had to do with the identity of acceptable research. I freely admit that I wrote poetry and fiction long before I ever thought to try my hand at research writing. I will also confess the same admission as Richardson in that for years . . .

. . . I have yawned my way through numerous supposedly exemplary qualitative studies. Countless numbers of texts have I abandoned half-read, half-scanned. I'll order a new book with great anticipation—the topic is one I'm interested in, the author

is someone I want to read—only to find the text boring. (Richardson, 1997, p. 87)

I held the fear that this new form of writing demanded of doctoral study would eviscerate my senses, leaving me a stuffed human in a glass box in a scene right out of The Planet of the Apes, burying my artistic imagination in hermetic hermeneutic documentation. Gross and Levitt (1998), in their book *Higher Superstition: The Academic Left and Its Quarrels with Science*, make harsh characterizations of ways of knowing that are other than scientific as "muddleheadedness" (p. 1), "insularity and ignorance" (p. 7), "symbolic wish-fulfillment" (p. 8), "weakness of fact and logic" (p. 8), "unprovable and bootless speculation" (p. 12), "trendy doctrine, windy generalization" (p. 37), "tooth-fairy hypothesis" (p. 47), "incoherent" (p. 51), "hallucinatory" (p. 52), "hermeneutic hootchy-koo" (p. 53), "untrammeled relativism" (p. 84), "philosophical styrofoam" (p. 98), "intellectual tinsel" (p. 100), "febrile delusion" (p. 103), "metaphors" (p. 112), "academic inner city" (p. 136), "moonbeams and fairydust" (p. 176), "unsupported by any evidence" (p. 211), and "pathetic gullibility" (p. 212).

As a visual and performing artist, I excel at the construction and interpretation of meaning that is not just observable but also felt, thus rarely reproducible, and often unmeasurable. However, to be stigmatized as an occupier of second-class status as a knowledge-maker or relegated to an unfinished room just beneath the gabled rooftop of accepted research is an unacceptable position for me. In opposition to the fear of invalidation, my dissertation has attempted to move the goalposts.

My third fear and limitation had to do with the identity of the profession of art education itself and the nature of theory-building. Art educator Graeme Sullivan has challenged readers with the inquiry, "Is there an identity crisis for art education?" (Sullivan, 1999, p. 43). The question is provocative, suggesting that the art education community may be en-

sconced within a framework that has stifled its ability to thrive. How can I function within a field that does not fully accept the extraordinary efficacy of its own aesthetic practices towards the creation of new knowledge?

In his discussion of *practitioner theorizing*, Sullivan argues that it is time for the field of art education to embrace that "the challenge of theorizing studio art practice requires the construction of a robust and defensible framework for considering the relationship between the theories and the practices that inform how art is made and how it can be studied and taught" (Sullivan, 2004, p. 801).

In my dissertation, I utilized an improvisatory arts-based research approach to craft—both in process and in presentation—a research methodology that critiques the rigidity of Western ontological and epistemological structures from within the structure of a dissertation required to meet institutional standards. I engaged in a multi-genre writing process incorporating prose, poetry, found imagery, and uniquely created works of art with the supposition that a blending of intuitive processes and logical formulations could most successfully represent the shape-shifting depiction of African American identity embedded within the socio-historical narrative of Western popular and visual culture. Art education blends both arts and sciences, and that means its curriculum, instruction, and assessment models cannot be derived solely from scientific methodology or industrial paradigms.

My dissertation was designed to pay heed to "metaphoric, synesthetic" ways of knowing (Eisner, 1994, p. 98). In opposition to the fear that art education is not being heard, I sought to produce a defensible, engaging, innovative, and eminently publishable piece of research. Ensconced both in personal and collective memory, it was important that my dissertation also be memorable and flexible as well.

The visual data I have presented in this study is intended for further debate. Within the contexts of

my own ongoing experience of normalizing and stigmatizing representations, Western visual culture says both that "I am a normal man," and that "I am an African-American." Conventional representations notwithstanding, the two positions are not mutually exclusive and swim in tandem. There are no fixed medians of normality and deviance; utter normality and utter deviance are unattainable exemplars in Western society. Both stereotypes have too much humanly in common. In proximity, they transfigure one another's purported strictures. Normal individuals fail. Stigmatized individuals rise, stigmata in hand, to "extra-normative" self-representations, namely the representation of personal identity as liberated from structured democratic confinements. (Rolling, 2003, p. 186)

How does the named body refigure itself? How do I sing of extra-normative bodies in a normal land? How do I validate my new names? It is through the representative arts that our angry hordes of stereotypes may be broken down into their innumerable possibilities. Identity, like art, is a hybrid creation. How does the word—or image—become flesh? I have argued that a poststructural identity can be created from the reinterpretation of identities, neither true nor false but rather, *felt.* The possibilities of all felt creations are ceaseless. (Rolling, 2003, pp. 187-188, emphasis in the original)

Visual Culture Archaeology

A poststructural research methodology revealing the grid of socially constructed narratives that together constitute what becomes "socially visible" as an acceptable, normalized, or stigmatized identity.

In my effort to craft a research methodology that critiqued the problem of marginalized identity from within Western epistemological structures, I invented a methodology I now call visual culture archaeology, an overwriting of a premise introduced by Michel Foucault which, in this instance, delves into images and image-making as constitutive narratives in the tectonic plates of Western culture (Rolling, 2007a). Visual culture archaeology reveals that there is a grid of socially constructed narratives that together constitute what becomes "socially visible" as an acceptable identity, as a range of credible reinterpretations of a normalized identity, and as a

range of stigmatizing shortcomings inhibiting so-
cial acceptability. Visual culture archaeology pro-
poses that it can identify these grids or matrices of
socially constructed narratives. Its methodology is
politicized and activated by its ability to render visi-
ble what is normally invisible.

Visual culture archaeology posits that it cannot
only identify a given grid of socially accepted narra-
tives, but also delineate shifts in the regularities that
shape the emergence of narrative reinterpretations.
In response to the investigation of the marked invis-
ibility of my identities within Western ways of
knowing, and in order to find a way to reconstitute
the legitimacy and significance I nonetheless feel
within my own experience, I chose to operate from
the position of my evident marginality and to ex-
pand those borders to move my saliencies toward
the center of academic discourses.

I do not have a single axis identity: I am not a
black man *or* a black artist *or* a critical black theorist
or a minority teacher educator; I am a cultural prac-
titioner, a colony of identities. "I" is therefore con-
stituted as "we" and, as is borne out in the variety of
motivations compelling me to research, we con-
tinue to be utterly incomplete.

Improvisatory Arts-Based Curriculum-making
Strategies for Educational Practice

Improvisational art-making practices offer combi-
natory approaches for teaching and learning that
may include material-specific, language-specific,
and/or critical-activist theory-building strategies—
constituting arts-based bodies of knowledge
"across" idiosyncratic modes of inquiry. Impro-
visatory arts-based curriculum-making recognizes
Thinking Reflexively as a viable exercise in learning
behavior. Self-study becomes a methodology for
meaning-making—and self becomes both the site
and an instrument for research or student learning.
Improvisational art-making practices yield at least

the following strategies for classroom learning, with more to be named by others.

Autoethnography (as teaching/learning strategy)

An improvisatory research and teaching/learning strategy negotiating rogue narratives of self and lived experience, superseding simplistic social delineations, stereotypes and authorized canons of identity.

Autoethnography is an improvisatory research and teaching/learning strategy negotiating rogue narratives of self and lived experience, superseding simplistic social delineations, stereotyped representations, and contending against authorized canons of identity. The artist John Feodorov employs this strategy in conceiving his works of art, drawing upon his experience growing up in both the suburbs of Los Angeles and on a Navajo reservation in New Mexico to negotiate stereotypes, spirituality and the "sacred" in direct confrontation with American consumer culture.

Performance Pedagogy

An improvisatory research and teaching/learning strategy interpolating and reintroducing narratives of self and lived experience, imagining new social delineations.

Performance pedagogy (Garoian, 1999) is an improvisatory research and teaching/learning strategy interpolating and reintroducing narratives of self and lived experience, imagining new social delineations, subverting representations, and playfully contesting prevailing forms of meaning. Oliver Herring employs performance pedagogy in his art-making practices. The following excerpt from the Art21 PBS website offers insights into Herring's unique time-based pieces involving stop-motion photography, video, and the participation of his audience in collaborative practice and performance:

> Among Herring's early works were his woven sculptures and performance pieces in which he knitted Mylar, a transparent and reflective material, into human figures, clothing, and furniture. These ethereal sculptures, which evoke introspection, mortality, and memory, are Herring's homage to Ethyl Eichelberger, a drag performance artist who committed suicide in 1991. Since 1998, Herring has created stop-motion videos and participatory performances with "off the street" strangers. He makes sets for his videos and performances with minimal means and materials, recycling elements from one artwork to the next. Open-ended and impromptu, Herring's videos have a dreamlike stream-of-consciousness quality; each progresses towards a finale

that is unexpected or unpredictable. Embracing chance and chance encounters, his videos and performances liberate participants to explore aspects of their personalities through art in a way that would otherwise probably be impossible. In a series of large-scale photographs, Herring documents strangers' faces after hours of spitting colorful food dye—recording a moment of exhaustion and intensity that doubles as a form of abstract painting. Herring's use of photography takes an extreme turn in his most recent series of photo-sculptures: for these works, Herring painstakingly photographs a model from all possible angles, then cuts and pastes the photographs onto the sculptural form of his subject. (Retrieved February 11, 2012 from http://www.pbs.org/art21/artists/oliver-herring)

An example of an improvisatory teaching/learning strategy successfully elicited through the art education curriculum is a project I taught involving 3rd and 4th grade students in an exploration of autobiography and life narrative as a source for curriculum-making and studio art (Rolling, 2007b). The "Who I Am" project was one of my final contributions to the lives of the children I worked with daily as a lead K-4 visual arts teacher for a new elementary school in New York City, originally conceived to espouse a fully integrated curricular format.

The project I proposed stemmed from a trip to New York City's El Museo del Barrio in March of 2005 with three 3rd grade classes of approximately 18 students each so as to view an exhibition titled *Retratos: 2000 Years of Latin American Portraits*. One of the striking features of this exhibition was how many of these touchstones of personal and political identity were physically embedded, inscribed, or otherwise represented upon the surface of these collected artifacts and then passed down from generation to generation as family heirlooms. In the art classroom following the exhibition, we began to discuss the questions: "What is an heirloom?" "Is it

valuable to the family because it is expensive, or are there reasons for its significance?" Unfortunately, the difficult logistics of arranging this particular trip pushed it back to a particularly busy time of the school year as we were approaching both Spring Recess and the end of the second trimester. Thus, a full-fledged art studio exploration on the significance of heirlooms was scratched as the third trimester thematic focus on "Justice" was instead launched. Nevertheless, I made a mental note to somehow revisit the inquiry on heirlooms during the Integrated Projects Week, or IPW, at the close of the final trimester.

An IPW was intended to involve small groups of students from different classes and grade levels in a focused and extended collaborative learning exercise. The self-selection of IPW inquiry projects allowed each student to deepen their understanding of a particular topic, theme, or concept already encountered in the curriculum and in which enrollees wish to cultivate an abiding interest. Final projects were then exhibited and/or performed in a culminating school-wide showcase to which all families were invited. At the end of the 2004-05 school year, I proposed the "Who I Am" storytelling project, wherein personal family artifacts, heirlooms and family stories were to serve as the inspiration for art-making, historical research, and the performance of self-image and family identity. A kindergarten teacher named Mr. Johns assisted me. The students who chose to participate in the "Who I Am" project were required to bring home a letter introducing the important notion of children relating family stories, while transforming meaningful personal objects or family heirlooms into works of art as an exploration of personal identity.

To inaugurate the "Who I Am" project, I gathered the participating students into an empty classroom. We sat down on a rug in a storytelling circle with a few learning objects on hand. First, I introduced *1260 Lincoln Place*, a mixed-media representation of my experience of the home I grew up in. It

incorporates a life-sized self-portrait, along with a portrait of my younger brother Dwayne, both of us visible in my childhood bedroom window. Each brick on the face of the exterior wall was hand-crafted and placed askew; the figures of the two boys were molded out of soil and clay. The careful modeling of their facial features was done with layer upon layer of oil pastels. The shirts worn by the two figures were cut from the rags of shirts we actually wore as children. The original working venetian blinds were actually taken from my old bedroom window. The print of the youngster playing baseball was a one-generation heirloom passed down to us; it was once hung on my father's bedroom wall when he himself was a boy and was valuable for no other reason. Too heavy to be passed around the story-telling circle as an object, my students were invited to step forward and touch the bricks and faces depicted in the artwork, as well as to raise and lower the blinds.

This first learning object was juxtaposed with some very old photographs that I subsequently passed around; the curriculum endeavor was intended to emerge from connections generated. The photographs belonged to the family albums of my friend Pam. I first met Dr. Pamela Harris Lawton when we were students of art education in the same doctoral cohort at Teachers College, Columbia University. She is now a member of the faculty and coordinator of the Art Education Program at the University of North Carolina at Charlotte. Like me, Pam is also a studio artist and arts-based researcher. Pam describes her effort to

> [condense] family stories, records and photographs into visual/verbal art pieces, making them easy to "read" and more widely accessible. I wanted to create visual documents that could be circulated, used to teach family history to the young, and yet be so aesthetically pleasing that instead of being filed safely away in a trunk, drawer or closet, be displayed as works of art in the homes of family mem-

bers where inquisitive young minds and eyes could seek them out and ask questions. (Pam Lawton, personal communication, February 12, 2006)

As I was conceiving the "Who I Am" project, I recalled viewing one such work of art exhibited by Pam several years prior at Teachers College, a work based upon her rescue of a family heirloom—a compact folding portable desk invented in the early 1940s by one of her recent ancestors, an accomplished architectural modelmaker and dollhouse designer named James W. Butcher. The original photographs and copies of newspaper articles that Pam was kind enough to send to me included photos of the heirloom in disrepair upon initial discovery and retrieval from some attic, basement, or closet. The portable desk was then photographed again after the loving act of family research, restoration, and storytelling orchestrated by Pam as she transformed the once-forgotten heirloom into a work of art. Regarding the portable desk and her reclamation of the legacy of her "Papa Will" (as Mr. Butcher was affectionately called amongst family members), Pam writes:

> Papa Will used wallpaper to decorate the sides of his desks. I peeled off the wallpaper and in place of it collaged prints and photocopies of photos and documents telling the story of Papa Will's life on the outside panels of the desk. And then because he was so involved in making things by hand, I had the idea of sculpting in clay a replica of his hands in the act of sketching ideas for future woodworking projects—in effect putting him into the piece. (Pam Lawton, personal communication, February 12, 2006)

After viewing both my work and Pam's work juxtaposed, handling all of the learning objects with care, the children in the storytelling circle were asked to draw upon their own life stories to make some connections of their own. What heirloom

from their home would they each like to ask permission from their parents to bring to class and transform into a work of art? The children considered the possibilities with much enthusiasm! Each child was given a sketchbook and asked to mark out some preliminary ideas for their projects as they came to mind.

Nyasa, one of my third grade students, saw the possibilities in juxtaposing her great grandmother's childhood long ago on the Caribbean island of Barbados, as compared to her own childhood in the present-day United States. The opportunity to make art in her elementary school classroom was further juxtaposed with a simple and precious family heirloom—a jar of sand carried from the beaches of Barbados when her great grandmother immigrated to these shores. In these juxtapositions, Nyasa found a connection that made sense to her, a story worth telling, a story of the passage of time and the passing down of meaning from one generation to the next. I asked all my students to write about and self-assess the significant idea at the core of their art-making:

My great grandmother came to this country with her two children and a jar of sand with her from the beach. She brought the sand with her as a reminder of Barbados. The sand is a piece of her country [and] it also represents if we can't be in Barbados, it will be with us... I began with the sand and thought about what I was going to do. I got the idea of making a timeline to show how the sand got passed down the family tree... I got the idea of using clay people to symbolize my family, giving the sand to one another. I put my great grandmother and my grandmother in the first box, my grandmother and mother in the second box and my mother and me in the third box... I got the idea of making it three-dimensional because I thought it would be weird if it was on paper. I also got the idea of how I want to tell the story. (Nyasa, personal communication, Spring 2005)

This was Nyasa's story, her own curriculum creation. Her homeroom class had been studying timelines and family trees during the recent school year; I had not been studying these things, and any suggestions I might have offered as drawn from my current experience would have led Nyasa in other directions. Fortunately, I had proposed to let the students initiate their own directions, make their own meanings, and to be on hand primarily to facilitate their constructions.

Shiva, one of my 4th grade students during the "Who I Am" project, was allowed to bend the rules a bit and literally chose his passport as the heirloom around which to build a work of art. Although the object itself had not been passed down from generation to generation, the *principle* of owning a personal passport was in fact a most authentic and powerful inheritance. Shiva explains:

> This passport is important because it shows my personal information and allows me to travel. With my passport I can go to different states and countries. With my passport I can also see new things, visit new places and meet new people. In these places I can find out how they live, why they like the way the live and what is important to them. When I see new things and monuments I ask myself questions such as why it was made, who made it and how old it is. I got my passport when I was 6 months old and it will expire in 2008. My first trip was a trip to India. I visit India every year to see my family. I have a large family. I wouldn't know many of them without my passport. Without this passport I would not have realized how lucky I am because some people do not have lucky lives. Some people don't have good schools, some children are working and there are all these other problems like world poverty and dirty hospitals. I consider myself lucky. (Shiva, personal communication, Spring 2005)

In the case of 4th grade student Dustin, his joy was palpable as he saw his great-grandmother for

the very first time. Dustin's personal family artifact was a green beret that first belonged to his great-grandmother, was passed down to his father, and then given to Dustin. According to Dustin, his great-grandmother Adda Bozeman spoke at military academies during the Vietnam War era and was an advocate in favor of the effectiveness of human intelligence over too great a reliance upon satellite surveillance in the practice of espionage. The green beret was apparently a gift to Dr. Bozeman in connection with one of these speeches. This was all that Dustin knew. He had never even seen a photograph of his great-grandmother.

I proceeded to help Dustin do a quick online search for his great-grandmother's name and we found out that she had been a Professor of International Relations at Sarah Lawrence College. Moreover, we discovered that the Sarah Lawrence College Archives had photographs of Dr. Bozeman in her role as an educator. I made an urgent request for digital copies of these photos on behalf of Dustin so that he could incorporate them into his project. Given the tight timeline, it was to our delight that our request was granted. For Dustin, receiving these photographs of a family member he had never met or seen was like uncovering a buried treasure! His parents had never seen these particular photos either, so Dustin was able to forward the images home, to his father especially, as a gift.

Tal, one of my 3rd grade students, was in the unique position of being a student in my regular day classroom twice a week, and a student signed up both to take my afterschool classes, and the extra week-long "Who I Am" IPW offering at the end of the semester. In the following previously published correspondence with Tal's mother Blair, who happens to be a research psychiatrist at a New York hospital, she introduces her son:

> I have a wonderful son named Tal (age 9) who has many talents. However, fine motor control and visual perception were not two of them. As a child, he

never drew—ever. It was unclear whether this was due to lack of interest, lack of skill, or some combination of the two. His passion was baseball, and you didn't need to draw to play shortstop. As a result, when he told me one day that his only complaint with his new school was that he did not have enough art time I was startled. Even more startling was when he signed up for "Master Portrait Drawing" as an afterschool class. He chose this class even though it required attendance twice a week for 2 hour sessions each, and it prevented him from playing afterschool basketball with his best friend. I kept my mouth shut as he filled out the afterschool form, but I wondered if he would even last one week. In fact, he lasted all semester, he chose an extra week of art at the end of the school year, and he lamented the fact that his teacher was moving away and would not be at school the following year. For the first time in his life, Tal liked drawing and looked forward to art class. (Rolling, 2006a, pp. 224, 225)

Why would a self-described sports fanatic who brought his baseball glove to school each day and expressed little to no interest in art before the 3rd grade take this curricular path, so seemingly at odds with his previous autobiographical tellings? Tal's mother followed her son's development closely that semester and noticed several things that were out of the ordinary.

The first thing I noticed as Tal worked week after week on his family portraits was that he began to notice visual details in the external world. Historically, this was a child who struggled to discern E from F or to find something in the refrigerator right in front of him . . . The second thing I noticed was his increasing ability to see both the forest and the trees. Historically, Tal had a tendency toward tunnel-vision: when he noticed a detail, he saw nothing else. He could get caught on one word in a sentence and miss the overall meaning. However, in art class, Tal was learning how to draw his

brother's face, which required that he draw his brother's two eyes, nose, mouth and teeth all in the right proportion to each other. Then, he drew his mother's eyes in his mother's face, his father's ears on his father's head, etc. To make his family portraits look like his family, Tal had to move back and forth between the forest (i.e., the overall effect) and the trees (i.e., the specific facial features). I began to notice his increasing ability to do this not only with his drawing but with his thinking as well. Whether drawing taught him to do this or whether he was ready to do this and drawing was a way to practice combining the part with the whole, I don't know. However, the growth in his conceptual flexibility was quite dramatic. (Rolling, 2006a, pp. 225, 226)

Tal's heirloom for the "Who I Am" project was a book from which his name was taken, titled *TAL, His Marvelous Adventures with Noom-Zor-Noom* (1929), by author Paul Fenimore Cooper, the great-grandson of the renowned early American novelist James Fenimore Cooper. Tal did not want to permanently affix this book into a work of art so he instead chose to make a small bookshelf made out of some thick corrugated cardboard we had tucked away in one of the art studio storage closets. Tal writes about his name, his family, and his "being here" in the following in-class writing:

When my mom was a kid her third grade teacher read her the book "Tal," she thought it was such a great and mysterious book. The only other person my mom knew who read the book outside of her class was her sister Lisa who had the same teacher when she was in third grade. Years later my mom met my dad. He also knew the book "Tal" because his uncle [Paul Fenimore Cooper] wrote the book. One of the earliest presents from my dad to my mom was the book "Tal"! My dad went to an out-of-print book shop, and found the book "Tal" and he gave it to my mom. They decided upon Tal as my

name because they both loved the book. But in the book the boy named Tal actually had blond hair and blue eyes. I have dark hair and brown eyes. (Tal, personal communication, Spring 2005)

The book was not the only object in Tal's pedagogical site installation; he also included several other exemplars of his identity in this telling. Incorporated into his bookshelf, Tal also included a baseball; a second heirloom, his baseball glove, which first belonged to his father and was passed on to Tal; a clay jaguar, Tal's favorite animal, made specifically for placement within the installation; a rolled paper "chessboard" hand-ruled and hand-inked by Tal, a replication of the soft vinyl chessboards favored by the Chess program he participated in; a copy of the front cover end paper so richly inked by the book's illustrator, Ruth Reeves, which was glued onto the lower shelf of the installation; other poetry and narratives written for the occasion; and a family photograph of Tal, his little brother and parents, glued to a small picture frame constructed by Tal, and set atop the completed bookshelf.

These particular elementary art studio responses are presented as evidence of the utility of improvisational approaches to art education practice prompted by autoethnography as an art-making and learning methodology. If all curriculum were to be conceived exemplifying qualities of lived experience and living inquiry in mind, I suspect that what our students learn in class today will remain just as relevant and accessible 10, 20, and 30 years in the future.

Glossary

Autoethnography (as teaching/learning strategy)—An improvisatory research and teaching/learning strategy negotiating rogue narratives of self and lived experience, superseding simplistic social delineations, stereotypes, and authorized canons of identity.

Combinatory—An improvisatory ABR research outcome intended to represent the multiple modes of an experience and multiple strategies for theory-building all at once.

Improvisatory Arts-Based Curriculum-making Strategy—A curriculum-making strategy for the arts and design in education that involves *thinking reflexively*, wherein the self becomes both the site and an instrument of research or student learning.

Intertextual—Intertextuality refers to a system of colliding interrelationships between the individual psyche, society, and the world that renders individual and social identity impossible to delimit or pin down.

Performance Pedagogy—An improvisatory research and teaching/learning strategy interpolating and reintroducing narratives of self and lived experience, imagining new social delineations.

Reflexivity—An approach to generating improvisatory ABR research outcomes through idiosyncratic methods for making meaning and recording knowledge.

Visual Culture Archaeology—A poststructural research methodology revealing the grid of socially constructed narratives that together constitute what becomes "socially visible" as an acceptable, normalized, or stigmatized identity.

References

Alvesson, M., & Sköldberg, K. (2000). *Reflexive methodology: New vistas for qualitative research*. London: Sage.

Anzaldúa, G. (1988). Bridges, drawbridge, sandbar, or island. In M. Blasius & S. Phelan (Eds.), *We are everywhere: A historical sourcebook of gay and lesbian politics* (pp. 712–722). New York: Routledge.

Aoki, T. (1978). Toward curriculum inquiry in a new key. In J. Victoria & E. Sacca (Eds.), *Presentations on art education research number 2, phenomenological description: Potential for research in art education* (pp. 47–69). Montreal: Concordia University.

Art21/PBS. (2001-2012). *Art:21: Art in the twenty-first century*. Retrieved from http://www.pbs.org/art21/

Bakhtin, M. (1984). *Problems of Dostoevsky's politics* (C. Emerson, Ed. and Trans.). Minneapolis, MN: University of Minnesota Press. (Original work published 1963).

Barone, T. (2006). Arts-based educational research then, now, and later. *Studies in Art Education, 48* (1), 4–8.

Barone, T., & Eisner, E. (2012). *Arts based research*. Thousand Oaks, CA: Sage.

Beer, R., & Grauer, K. (2011). Catch and release: Arts-based research and interdisciplinary pedagogical encounters with interactive new

media artwork within social history museums as informal learning sites. [Research brief submission for arts-based research primer]. Unpublished raw data.

Berger, J. (1972). *Ways of seeing.* London: Penguin Books.

Brown, L., & Strega, S. (Eds.). (2005). *Research as resistance: Critical, indigenous, & anti-oppressive approaches.* Toronto: Canadian Scholars' Press.

Bruner, J. (1995). The autobiographical process. *Current Sociology, 43* (2–3), 161–177.

Buchler, J. (Ed.). (1955). *Philosophical writings of Peirce.* New York: Dover.

Bucholtz, M. (1999). Bad examples: Transgression and progress in language and gender studies. In M. Bucholtz, A. C. Laing, & L. A. Sutton (Eds.), *Reinventing identities: The gendered self in discourse* (pp. 3–24). New York: Oxford University Press.

Cahnmann-Taylor, M. (2008). Arts-based research: Histories and new directions. In M. Cahnmann-Taylor & R. Siegesmund (Eds.), *Arts-based research in education: Foundations for practice* (pp. 3–15). New York: Routledge.

Cahnmann-Taylor, M., & Siegesmund, R. (Eds.). (2008). *Arts-based research in education: Foundations for practice.* New York: Routledge.

Cancienne, M. B., & Snowber, C. N. (2003). Writing rhythm: Movement as method. *Qualitative Inquiry, 9* (2), 237–253.

Carroll, K. L. (1997). Researching paradigms in art education. In S. D. La Pierre & E. Zimmerman (Eds.), *Research methods and methodologies for art education* (pp. 171–192). Reston, VA: National Art Education Association.

Cixous, H., & Sellers, S. (Eds.). (2004). *The writing notebooks of Hélène Cixous.* London: Continuum.

Cohen, L., Manion, L., & Morrison, K. (2000). *Research methods in education* (5th ed.) London: RoutledgeFalmer.

Cohen-Cruz, J. (2010). *Engaging performance: Theatre as call and response.* New York: Routledge Press.

Creswell, J. W. (1994). *Research design: Qualitative & quantitative approaches.* Thousand Oaks: Sage Publications.

Cronbach, L. J. (1975). Beyond the two disciplines of scientific psychology. *American Psychologist, 30,* 116–127.

Csikszentmihalyi, M. (1990). *Flow: The psychology of optimal experience.* New York: Harper and Row.

Deleuze, G., & Guattari, F. (1987). *A thousand plateaus: Capitalism and schizophrenia* (B. Massumi, Trans.) Minneapolis: University of Minnesota Press.

Denzin, N. K., & Lincoln, Y. S. (Eds.) (1998). *The landscape of qualitative research: Theories and issues.* Thousand Oaks, CA: Sage.

Derrida, J. (1978). *Writing and difference.* Chicago: University of Chicago Press.

Dewey, J. (1989). Art as experience. In J. Boydston (Ed.), *John Dewey: The later works, 1925–1953,* (pp. 1–400). Carbondale: Southern Illinois University Press. (Original work published 1934)

Dewey, J. (2005). *Democracy and education.* Stillwell, KS: Digireads.com Publishing. (Original work published 1916)

Eisner, E. W. (1965). Curriculum ideas in a time of crisis. *Art Education, 18* (7), 7–12.

Eisner, E. W. (1994). *The educational imagination: On the design and evaluation of school programs.* New York: Macmillan.

Eisner, E. W. (1997). The promise and perils of alternative forms of data representation. *Educational Researcher, 26* (6), 4–9.

Eisner, E. W. (2002). *The arts and the creation of mind.* New Haven & London: Yale University Press.

Eisner, E. W. (2006). Does arts-based research have a future? *Studies in Art Education, 48* (1), 9–18.

Eisner, E. W. (2008). Persistent tensions in arts-based research. In M. Cahnmann-Taylor & R. Siegesmund (Eds.), *Arts-based research in education: Foundations for practice* (pp. 16–27). New York: Routledge.

Foucault, M. (1972). *The archaeology of knowledge and the discourse on language* (Sheridan Smith, A. M., Trans.). New York: Pantheon.

Garoian, C. R. (1999). *Performing pedagogy: Toward an art of politics.* New York: State University of New York Press

Geertz, C. (1983). *Local knowledge: Further essays in interpretive anthropology.* New York: Basic Books.

Gergen, K. (1991). *The saturated self: Dilemmas of identity in contemporary life.* New York: Basic Books.

Giorgi, A. (1970). *Psychology as a human science: A phenomenologically based approach.* New York: Harper & Row.

Giroux, H. A. (1995). Borderline artists, cultural workers, and the crisis of democracy. In C. Becker & A. Wiens (Eds.), *The artist in society: Rights, roles, and responsibilities* (pp. 4–14). Chicago: New Arts Examiner Press.

Goffman, E. (1963). *Stigma: Notes on the management of a spoiled identity.* New York: Simon & Schuster, Inc.

Gould, S. J. (1981/1996). *The mismeasure of man.* New York: W. W. Norton & Company.

Gross, P. R., & Levitt, N. (1998). *Higher superstition: The academic left and its quarrels with science*. Baltimore: Johns Hopkins University Press.

Guba, E. G. (Ed.) (1990). *The paradigm dialog*. Newbury Park, CA: Sage Publications, Inc.

Habermas, J. (1971). *Knowledge and human interests*. (J. J. Shapiro, Trans.) Boston: Beacon Press.

Habermas, J. (1985). *The theory of communicative action* (Vol. 1 & 2). (T. McCarthy, Trans.). New York: Beacon Press.

Henry, J. (2002). *The scientific revolution and origins of modern science*. (2nd ed.) New York: Palgrave.

Herising, F. (2005). Interrupting positions: Critical thresholds and queer pro/positions. In L. Brown & S. Strega (Eds.), *Research as resistance: Critical, indigenous, & anti-oppressive approaches* (pp. 127–151). Toronto: Canadian Scholars' Press.

Hodgson, D. (2000). Art, perception and information processing: An evolutionary perspective. *Rock Art Research, 17* (1), 3–34.

Holland, K. J. (2011). *The Habermas machine: Conceptual art as philosophical inquiry*. [Research brief submission for arts-based research primer]. Unpublished raw data.

hooks, b. (1990). *Yearning: Race, gender, and cultural politics*. Boston: South End Press.

Hoy, W. K. (2010). *Quantitative research in education: A primer*. Thousand Oaks: Sage Publications.

Irwin, R. L. (2004). A/r/tography: A metonymic métissage. In R. L. Irwin & A. de Cosson (Eds). *A/r/tography: Rendering self through arts-based living inquiry* (pp. 27-40). Vancouver: Pacific Educational Press.

Irwin, R. L., & de Cosson, A. (Eds.). (2004). *A/r/tography: Rendering self through arts-based living inquiry*. Vancouver: Pacific Educational Press.

Irwin, R. L., & Springgay, S. (2008). A/r/tography as practice-based research. In M. Cahnmann-Taylor & R. Siegesmund (Eds.), *Arts-based research in education: Foundations for practice* (pp. 103–124). New York: Routledge.

James, W. (1890/1952). *The principles of psychology* (Vol. 1). New York: Henry Holt.

Kaplan, A. (1964). *The conduct of inquiry: Methodology for behavioral science*. San Francisco: Chandler.

Kerlinger, F. N. (1986). *Foundations of behavioral research* (3rd ed.) New York: Holt, Rinehart, & Winston.

Kirk, R. A. S. (2011). *The nature of insecurity as it relates to artistic identity.* [Research brief submission for arts-based research primer]. Unpublished raw data.

Knowles, J. G., & Cole, A. L. (Eds.) (2008). Handbook of the arts in qualitative research: Perspectives, methodologies, examples, and issues. Thousand Oaks, CA: Sage Publications.

Kosmaoglou, S. (2006, April). *Holding myself up by my shoe-strings.* Unpublished paper presented at the fifth annual Discourse, Power, Resistance conference titled "Research as a Subversive Activity." Manchester, UK.

Kuhn, T. S. (1962/1996). *The structure of scientific revolutions* (3rd ed.) Chicago: The University of Chicago Press.

Lather, P. A. (1990). Reinscribing otherwise: The play of values in the practices of the human sciences. In E. Guba (Ed.) *The paradigm dialog* (pp. 315–332). Newbury Park, CA: Sage Publications, Inc.

Lawrence-Lightfoot, S., & Davis, J. H. (1997). *The art and science of portraiture.* San Francisco: Jossey-Bass.

Leavy, P. (2009). *Method meets art: Arts-based research practice.* New York: The Guilford Press.

Lincoln, Y. S., & Guba, E. G. (1985). *Naturalistic inquiry.* Newbury Park, CA: Sage Publications, Inc.

Macleod, K., & Holdridge, L. (Eds.). (2006). *Thinking through art: reflections on art as research.* London and New York: Routledge.

Marshall, B. K. (1992). *Teaching the postmodern: Fiction and theory.* New York: Routledge.

May, T. (Ed.) (2002). *Qualitative research in action.* Thousand Oaks, CA: Sage.

McCartney, L. L. (2011). *Unpacking self in clutter and cloth: Curator as artist/researcher/teacher.* [Research brief submission for arts-based research primer]. Unpublished raw data.

Meadows, D. H. (2008). *Thinking in systems: A primer.* White River Junction, VT: Chelsea Green Publishing Company.

Mills, C. W. (1959). *The sociological imagination.* New York: Oxford University Press.

Morales, T. I. (2011a). *Research brief: An analytical methodology for a physical problem.* [Research brief submission for arts-based research primer]. Unpublished raw data.

Morales, T. I. (2011b). *Research brief—clarification: An analytical methodology for a physical problem.* [Research brief submission for arts-based research primer]. Unpublished raw data.

Nachmanovitch, S. (1990). *Free play: The power of improvisation in life and the arts.* New York: Tarcher/Putnam Books

Nandy, A. (1983). *The intimate enemy: The loss and recovery of self under colonialism.* Delhi: Oxford University Press.

Newton, R. M. (2005). Learning to teach in the shadows of 9/11: A portrait of two Arab American preservice teachers. *Qualitative Inquiry, 11* (1), 81–94.

Partnership for 21st Century Skills. (2008). *21st century skills, education, & competitiveness: A resource and policy guide.* Tuscon, AZ: Partnership for 21st Century Skills.

Pearse, H. (1983). Brother, can you spare a paradigm? The theory beneath the practice. *Studies in Art Education, 24* (3), 158–163.

Pearse, H. (1992). Beyond paradigms: Art education theory and practice in a postparadigmatic world. *Studies in Art Education, 33* (4), 244–252.

Perumal, J. (2006). Sketching the identity politics divide and its implications for transformative education. *Social Identities, 12* (6), 727–743.

Pinar, W. F. (2004). *What is curriculum theory?* Mahwah, New Jersey: Lawrence Erlbaum Associates, Inc.

Prawat, R. S. (1999). Dewey, Peirce, and the learning paradox. *American Educational Research Journal, 36* (1), 47–76.

Reeder. L. (2011). *Exquisite corpse: Thinking through analytic metaphor.* [Research brief submission for arts-based research primer]. Unpublished raw data.

Reese, W. L. (1980). *Dictionary of philosophy and religion.* Atlantic Highlands, NJ: Humanities Press.

Richardson, L. (1997). *Fields of play: Constructing an academic life.* New Brunswick, NJ: Rutgers University Press.

Rolling, J. H. (2003). *Un-naming the story: The poststructuralist repositioning of African-American identity in western visual culture.* Unpublished doctoral dissertation, Teachers College, Columbia University. New York, New York.

Rolling, J. H. (2004). Messing around with identity constructs: Pursuing a poststructural and poetic aesthetic. *Qualitative Inquiry, 10* (4), 548–557.

Rolling, J. H. (2006a). Marginalia and meaning: Off-site/sight/cite points of reference for extended trajectories in learning. *Journal of Social Theory in Art Education, 26*, pp. 219–240.

Rolling, J. H. (2006b). Who is at the city gates? A surreptitious approach to curriculum-making in art education. *Art Education, 59* (6), 40–46.

Rolling, J. H. (2007a). Visual culture archaeology: A criti/politi/cal methodology of image and identity. *Cultural Studies↔Critical Methodologies, 7* (1), 3–25.

Rolling, J. H. (2007b). Exploring Foshay's theorem for curriculum-making in education: An elementary school art studio project. *Journal of Curriculum & Pedagogy, 4* (1), 136–159.

Rolling, J. H. (2008a). Rethinking relevance in art education: Paradigm shifts and policy problematics in the wake of the Information age. *International Journal of Education & the Arts, 9* (Interlude 1). Retrieved May 11, 2008 from http://www.ijea.org/v9i1/.

Rolling, J. H. (2008b). Sites of contention and critical thinking in the elementary art classroom: A political cartooning project. *International Journal of Education & the Arts, 9* (4). Retrieved June 16, 2008 from http://www.ijea.org/v9n7/.

Rolling, J. H. (2009). A paradigm analysis of arts-based research and implications for education. *Studies in Art Education, 51* (2), 102–114.

Rolling, J. H. (2011). Circumventing the imposed ceiling: Art education as resistance narrative. *Qualitative Inquiry. 17* (1), 99–104.

Rolling, J. H., & Brogden, L. M. (2009). Two or more hours away from most things: Re:writing identities from no fixed address. *Qualitative Inquiry, 15* (7), 1139–1154.

Schwandt, T. R. (1990). Paths to inquiry in the social disciplines: Scientific, constructivist, and critical theory methodologies. In E. Guba (Ed.) *The paradigm dialog* (pp. 258–276). Newbury Park, CA: Sage Publications, Inc.

Sharma, M. (2011). *Negotiating fields: Mapping pedagogies of Indian art education with Deleuzian and postcolonial narratives.* [Research brief submission for arts-based research primer]. Unpublished raw data.

Siegesmund, R., & Cahnmann-Taylor, M. (2008). The tensions of arts-based research in education reconsidered: The promise for practice. In M. Cahnmann-Taylor & R. Siegesmund (Eds.), *Arts-based research in education: Foundations for practice* (pp. 231–246). New York: Routledge.

Silverman, D. (2007). *A very short, fairly interesting and reasonably cheap book about qualitative research.* London: Sage Publications.

Sinner, A., Leggo, C., Irwin, R. L., Gouzouasis, P., Grauer, K. (2006). Arts-based educational research dissertations: Reviewing the practices of new scholars. *Canadian Journal of Education, 29* (4), 1223–1270.

Skrtic, T. M. (1990). Social accommodation: Toward a dialogical discourse in educational inquiry. In E. Guba (Ed.) *The paradigm dialog.* (pp. 125–135). Newbury Park, CA: Sage Publications, Inc.

Slattery, P. (2001). The educational researcher as artist working within. *Qualitative Inquiry, 7* (3), pp. 370–398.

Spencer, H. (1866). *Education: Intellectual, moral, and psychological.* New York: D. Appleton.

Springgay, S. (2002). Arts-based research as an uncertain text. *The Alberta Journal of Educational Research, 48* (3), 1–30.

Steiner, E. (1988). *Methodology of theory building.* Sydney: Educology Research Associates.

Stewart, M. G., & Walker, S. R. (2005). *Rethinking curriculum in art.* Worcester, MA: Davis Publications, Inc.

Strega, S. (2005). The view from the poststructural margins: Epistemology and methodology reconsidered. In L. Brown & S. Strega (Eds.), *Research as resistance: Critical, indigenous, & anti-oppressive approaches* (pp. 199–235). Toronto: Canadian Scholars' Press.

Sullivan, G. (1999). An identity crisis for art education. *Artlink: Australian Contemporary Art Quarterly, 19* (2), pp. 43–44.

Sullivan, G. (2004). Studio art as research practice. In E. W. Eisner &. M. D. Day (Eds.), *Handbook of research and policy in art education* (pp. 795–814). Mahwah, NJ: Lawrence Erlbaum Associates, Inc.

Sullivan, G. (2010). *Art practice as research: Inquiry in visual arts* (2nd ed.). Thousand Oaks: Sage Publications.

Taylor, P. G., Wilder, S. O., & Helms, K. R. (2007). Walking with a ghost: Arts-based research, music videos, and the re-performing body. *International Journal of Education & the Arts, 8* (7). Retrieved March 12, 2008 from http://ijea.asu.edu/v8n7/.

The Gardner School. (2006). Emergent curriculum. Retrieved June 6, 2006, from http://www.gardnerschool.org/emergentcurriculum. html

Tillett, W. (2011a). *Living the questions.* Unpublished doctoral dissertation. University of Illinois at Chicago.

Tillett, W. (2011b). *Living the questions.* [Research brief submission for arts-based research primer]. Unpublished raw data.

Wilson, B. (1997). The second search: Metaphor, dimensions of meaning, and research in art education. In S. La Pierre & E. Zimmerman (Eds.), *Research methods and methodology for art education* (pp. 1–32). Reston, VA: National Art Education Association.

Wilson, J. M. (1998). Art-making behavior: Why and how arts education is central to learning. *Art Education Policy Review, 99* (6), 26–33.

Zeiger, P. (n.d.). *Scientific method in the social sciences.* Retrieved from http://www.sdp.org/sdp/spirit/SocSci.htm

Index

Peter Lang PRIMERS

in Education

Peter Lang Primers are designed to provide a brief and concise introduction or supplement to specific topics in education. Although sophisticated in content, these primers are written in an accessible style, making them perfect for undergraduate and graduate classroom use. Each volume includes a glossary of key terms and a References and Resources section.

Other published and forthcoming volumes cover such topics as:

- Standards
- Popular Culture
- Critical Pedagogy
- Literacy
- Higher Education
- John Dewey
- Feminist Theory and Education

- Studying Urban Youth Culture
- Multiculturalism through Postformalism
- Creative Problem Solving
- Teaching the Holocaust
- Piaget and Education
- Deleuze and Education
- Foucault and Education

Look for more Peter Lang Primers to be published soon. To order other volumes, please contact our Customer Service Department:

 800-770-LANG (within the US)
 212-647-7706 (outside the US)
 212-647-7707 (fax)

To find out more about this and other Peter Lang book series, or to browse a full list of education titles, please visit our website:

www.peterlang.com